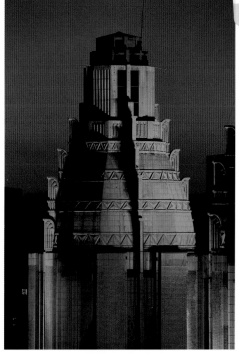

RIZZOLI
NEW YORK

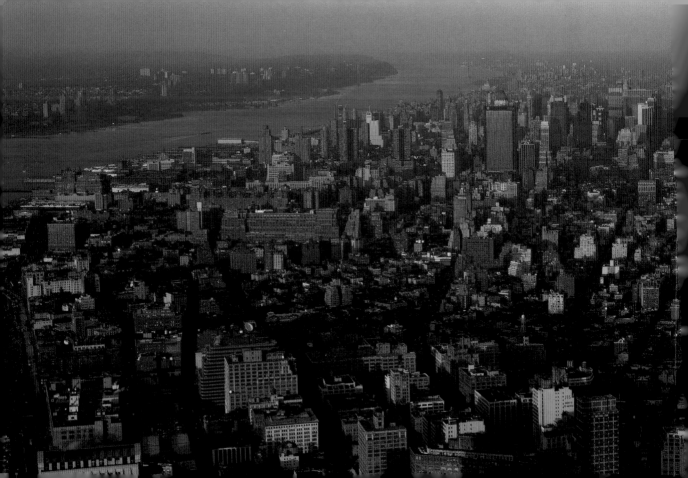

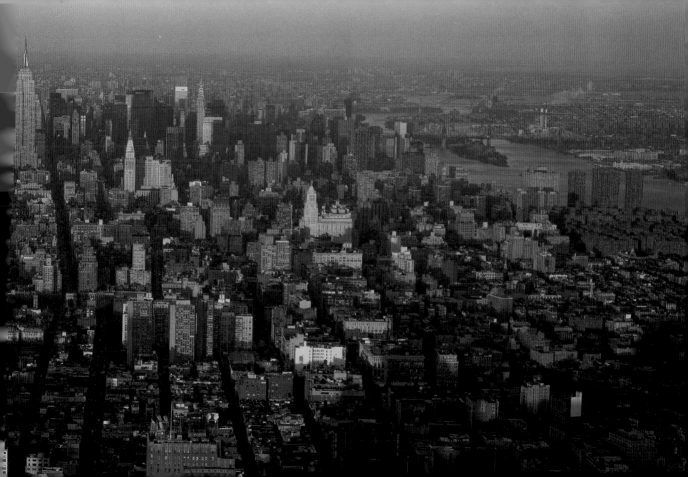

RICHARD BERENHOLTZ

NEW YORK

NEW YORK

FOREWORD BY KENNETH T. JACKSON

A WELCOME BOOK

RIZZOLI INTERNATIONAL PUBLICATIONS, INC.

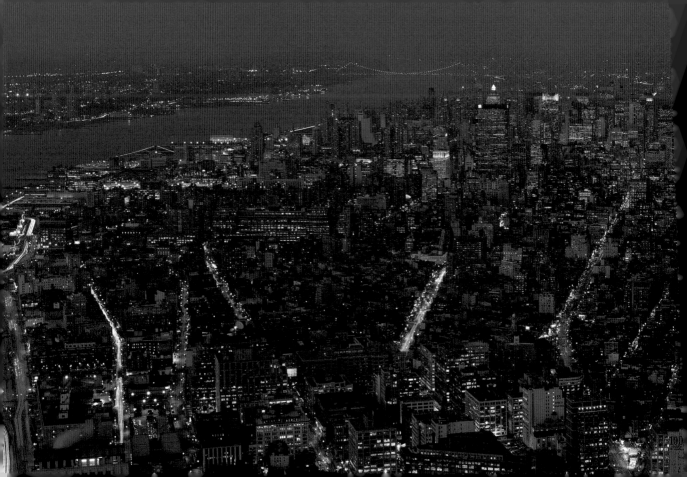

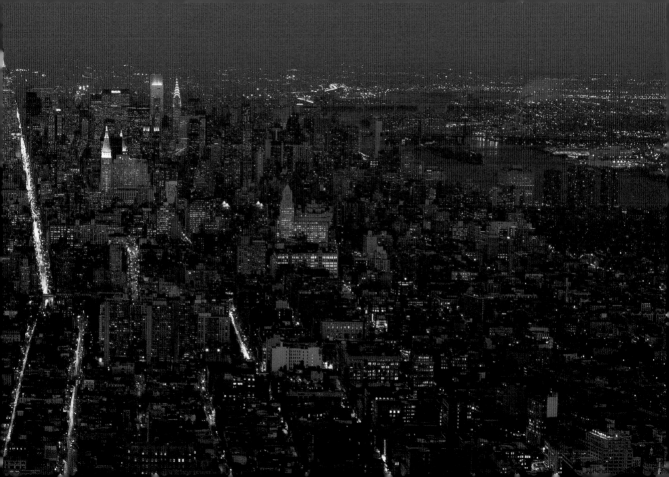

8

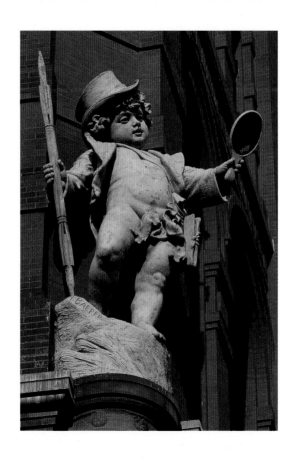

For my son Jack
a fifth-generation New Yorker

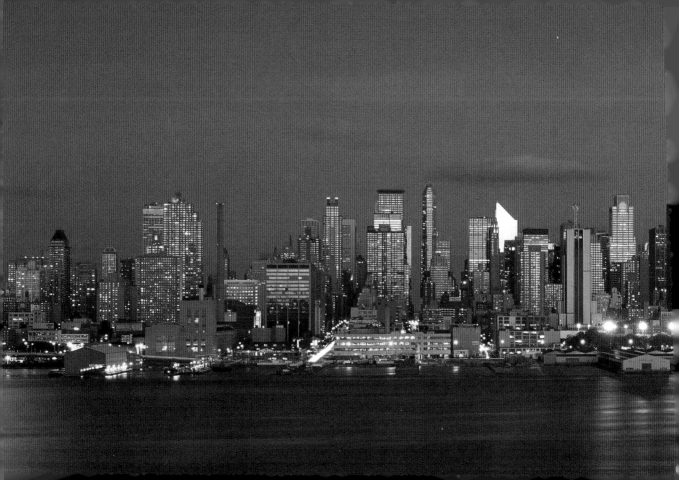

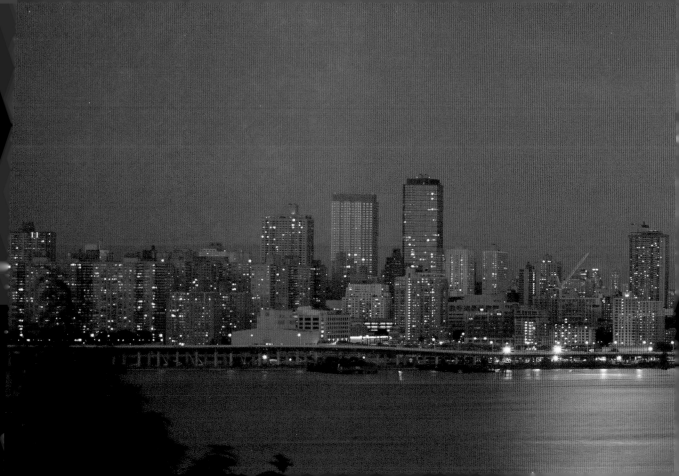

FOREWORD

GREAT CITIES HAVE DOMINATED the globe for several thousand years, and at least since Plato, Socrates, and Aristotle made Athens a vibrant intellectual and philosophical center of the ancient world. Since then, a number of other magical places—especially Rome, Beijing, Tokyo (Edo), Constantinople, Venice, Paris, and London—have in turn become the economic, political, and cultural center of civilization itself.

New York inherited the mantle of world leadership from London in the twentieth century perhaps in 1917, when debt-plagued Great Britain had to turn to Wall Street to finance World War I. Certainly by 1950, New York became the locus of leadership for the world when the establishment of the United Nations on the east side of Manhattan gave physical representation to a new kind of world order, in which the United States of America played a dominant part.

Gotham, of course, is not and has never been much like its European and Asian predecessors. Unlike them, it was never the national capital (1785–1790 a temporary exception) and never the official seat of empire. Unlike them, it never pointed to dozens of century-old buildings as emblematic of its glory. And unlike them, it never drew much attention to its storied past.

Similarly, New York has long had a distinctiveness and a greatness that are all its own. Everyone has a particular way of defining the Hudson River metropolis. Some notice instantly and instinctively its unusual heterogeneity, which has been characteristic of the community since the Dutch first set up shop on Manhattan in 1624. Indeed, visitors to the seventeenth century settlement marveled that eighteen separate languages were spoken on its streets at a time when its total population was below

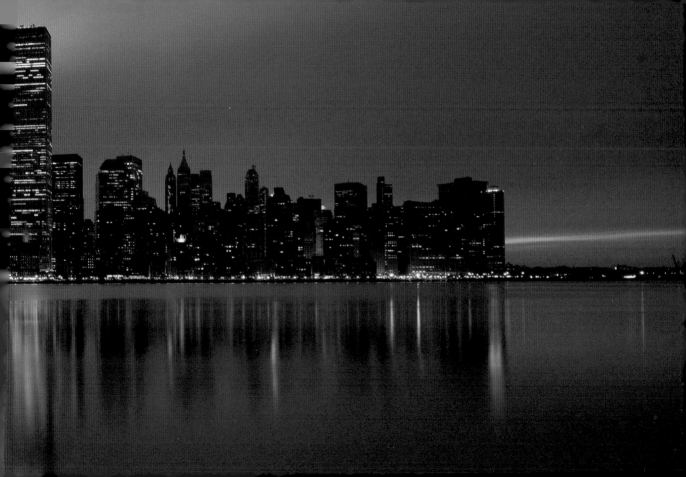

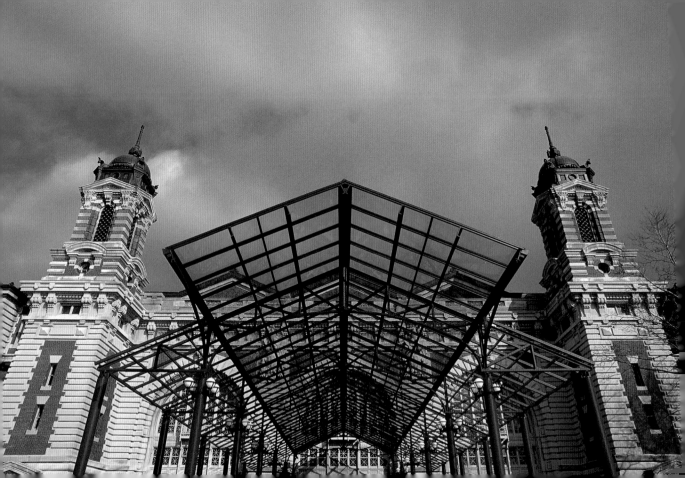

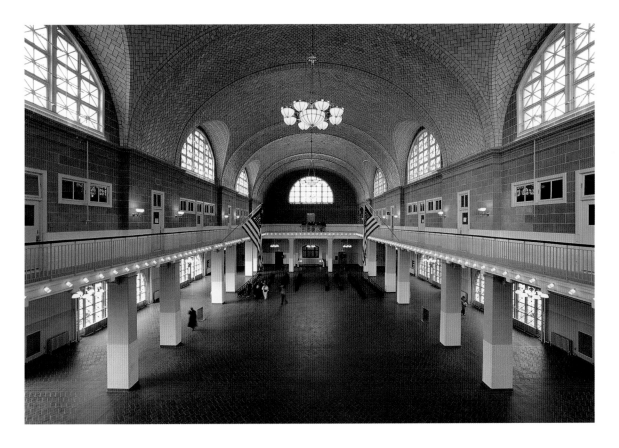

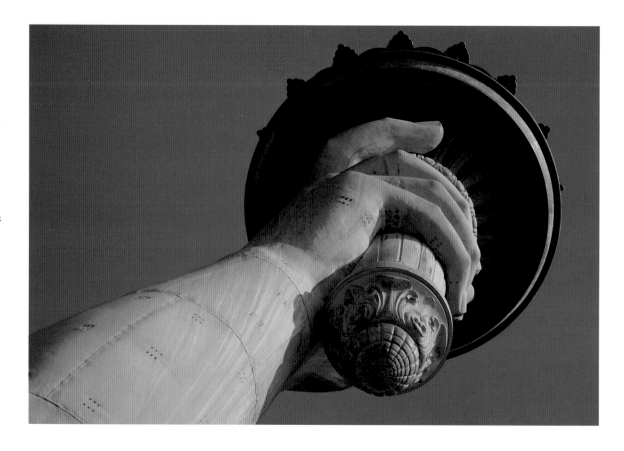

22

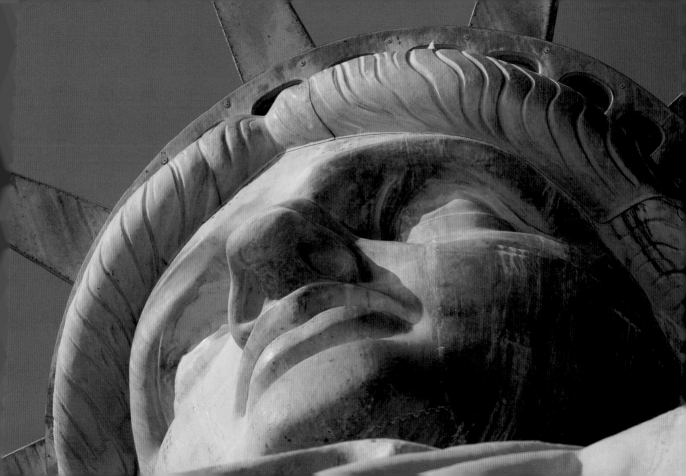

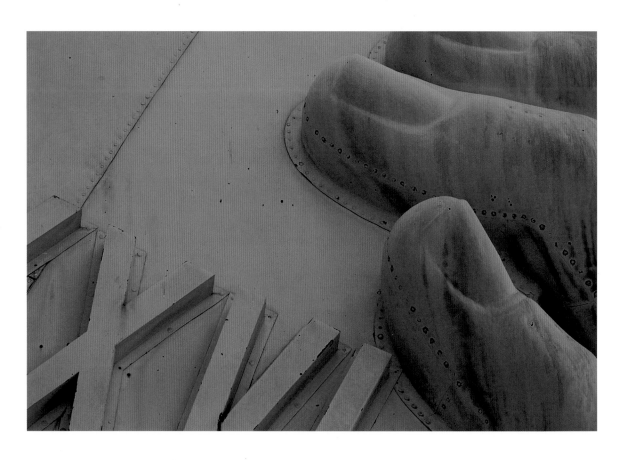

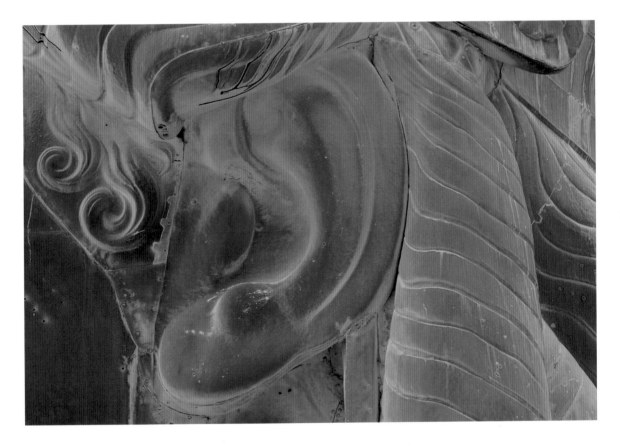

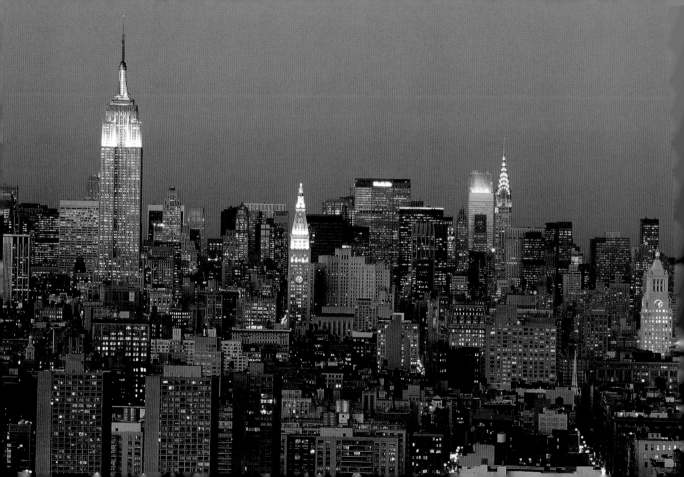

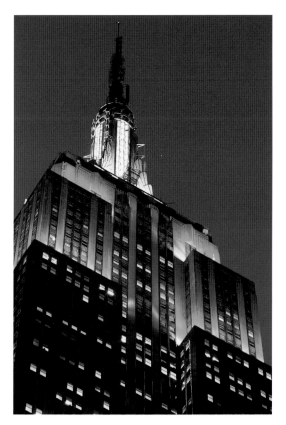
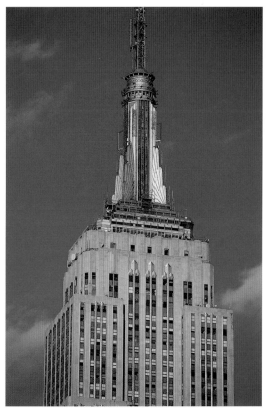

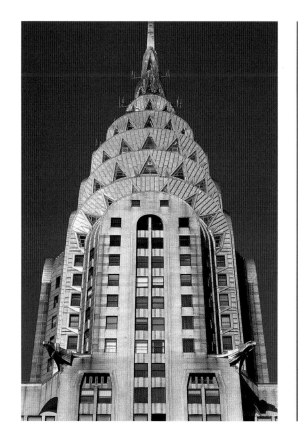

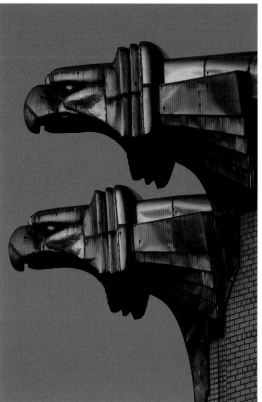

32

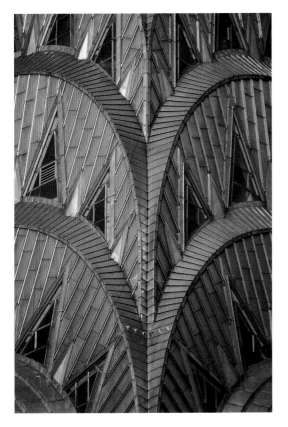
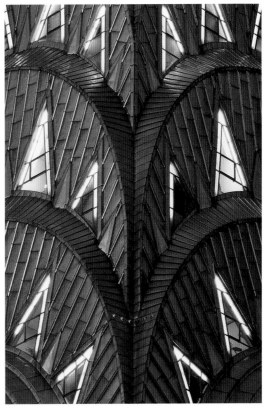

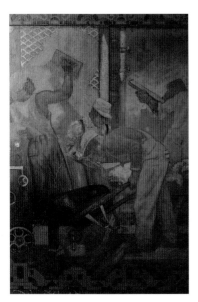
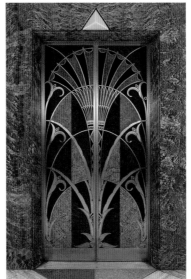
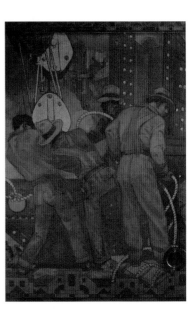

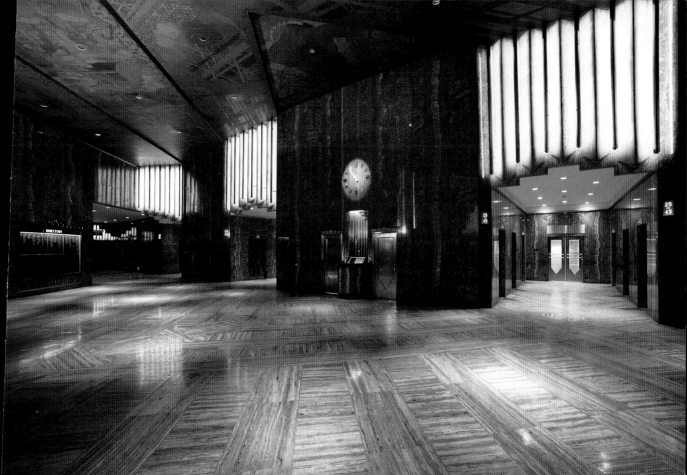

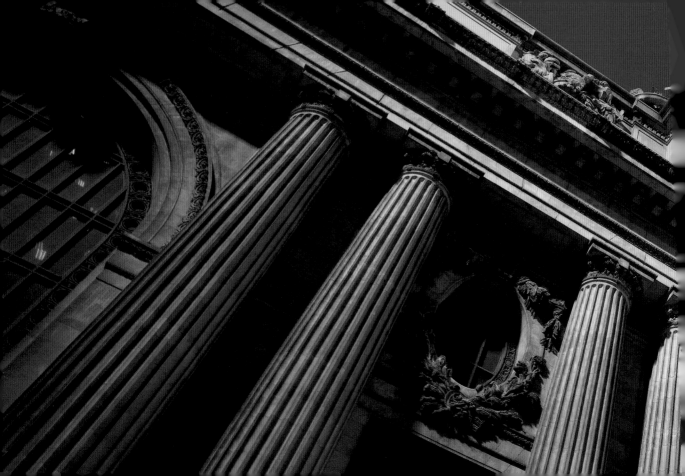

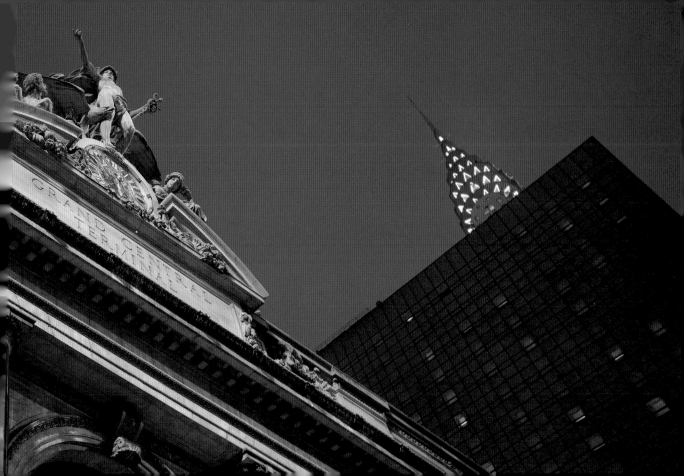

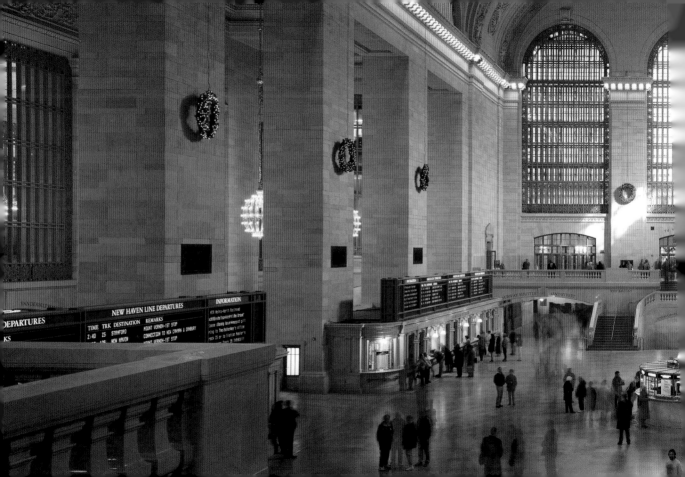

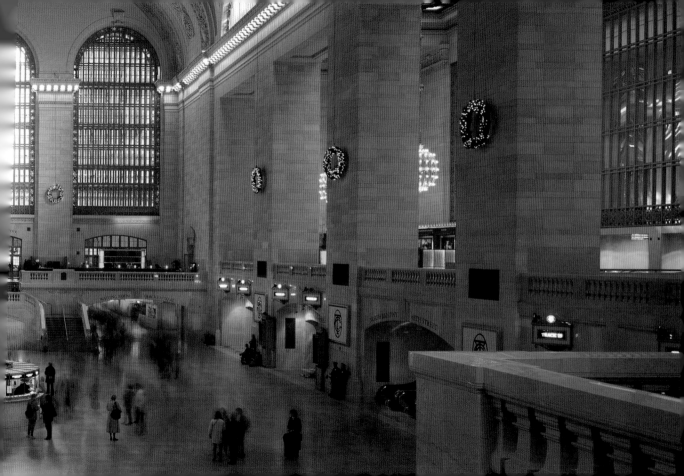

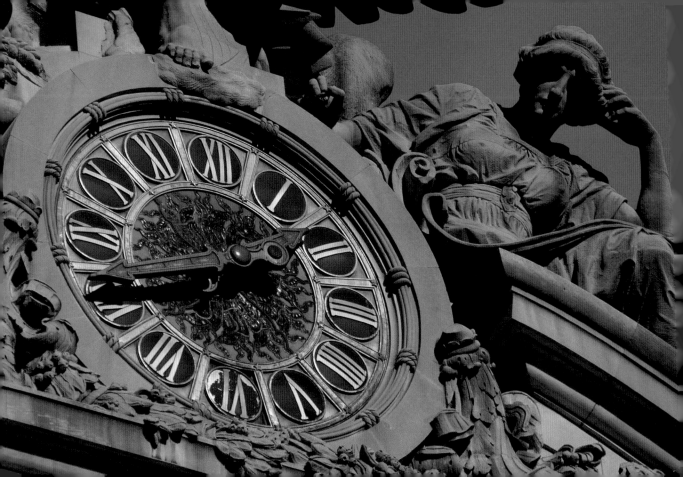

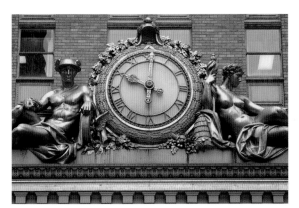

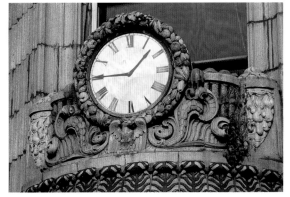

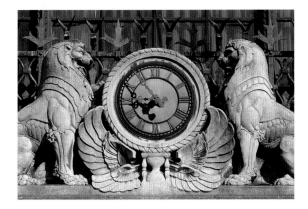

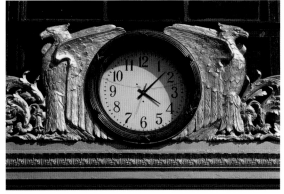

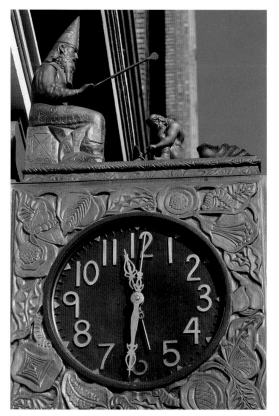

44

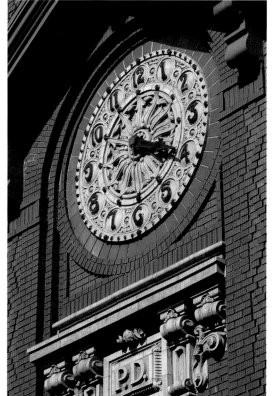

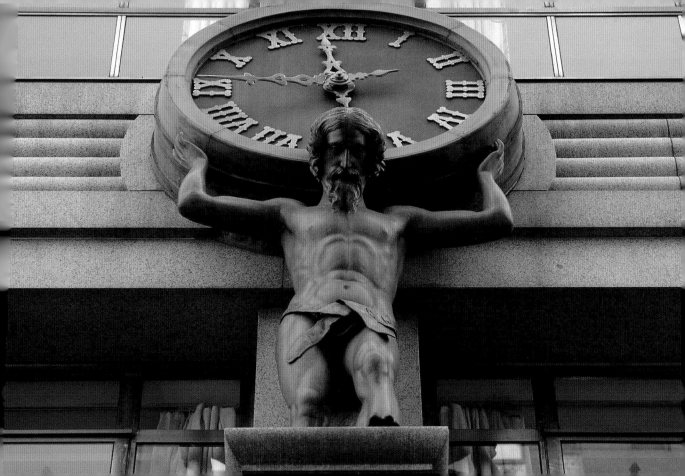

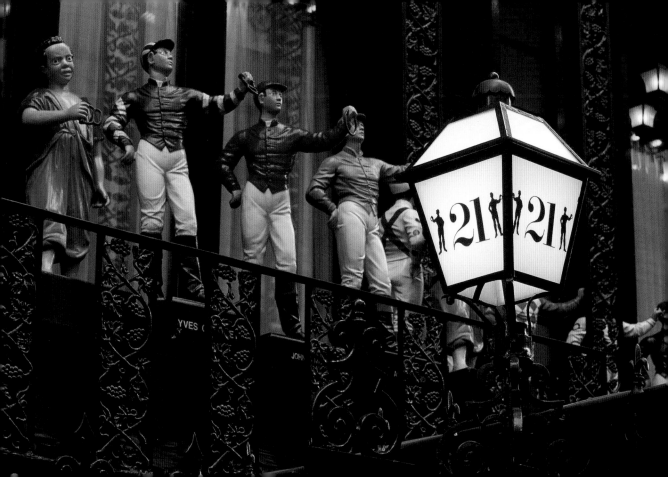

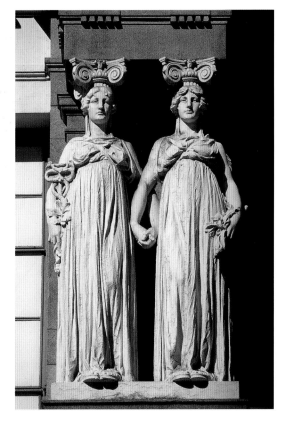

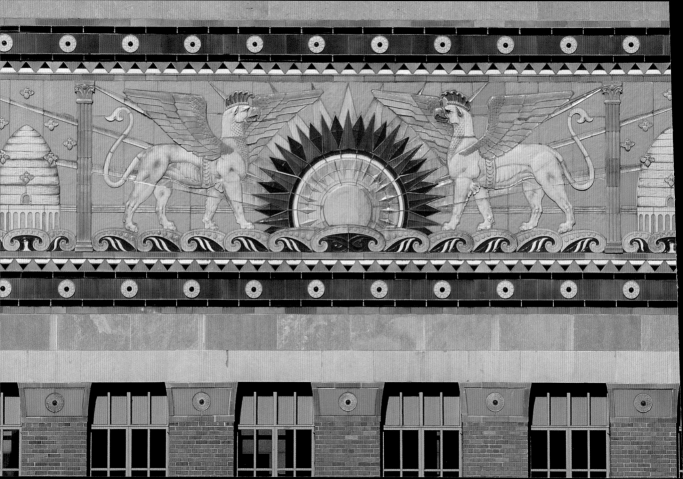

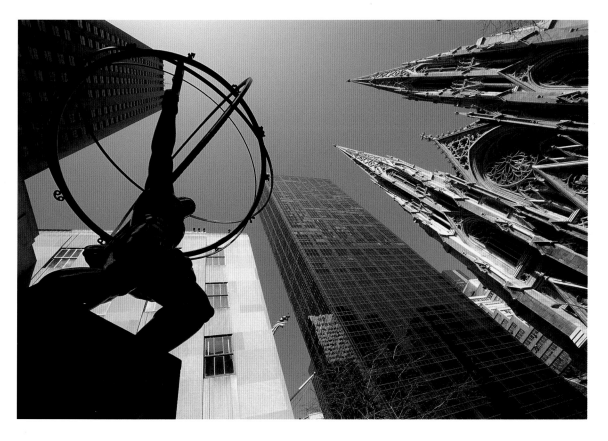

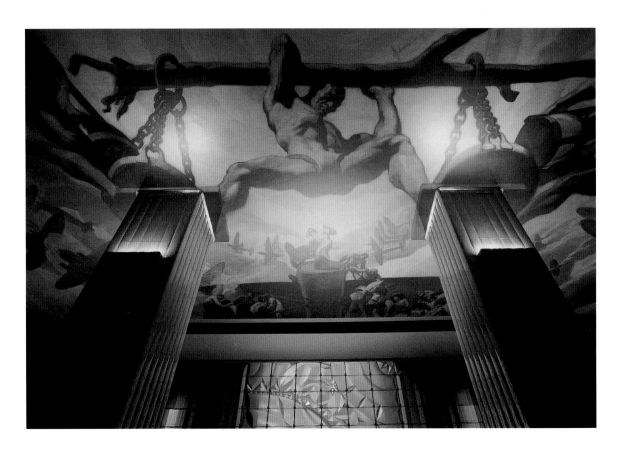

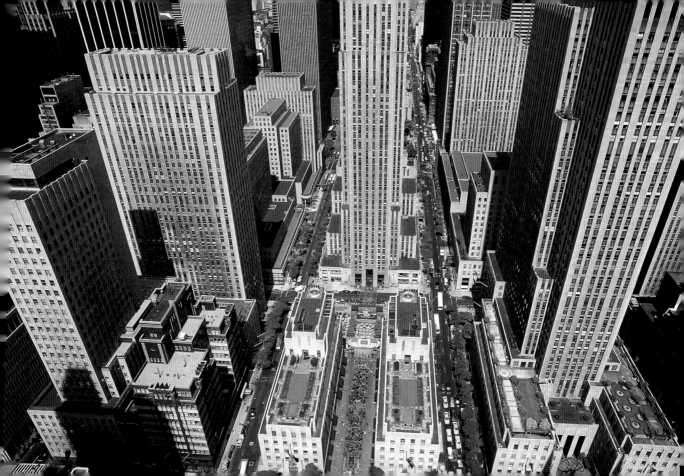

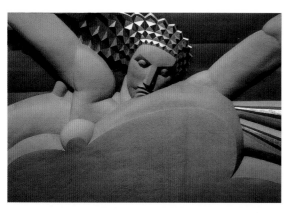

52

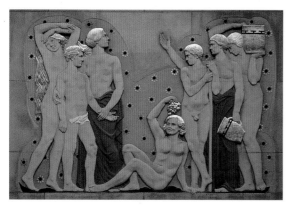

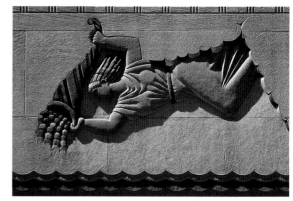

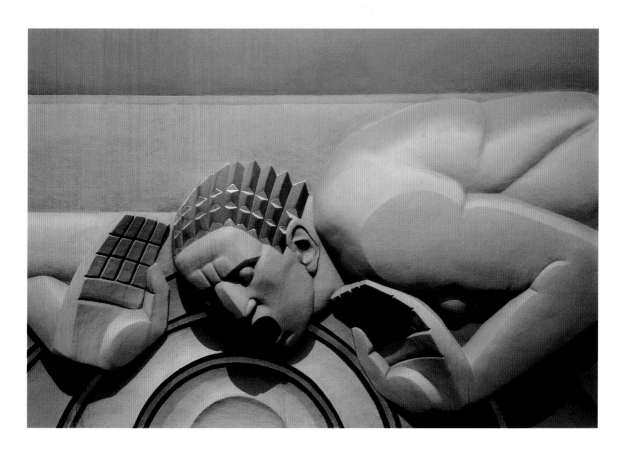

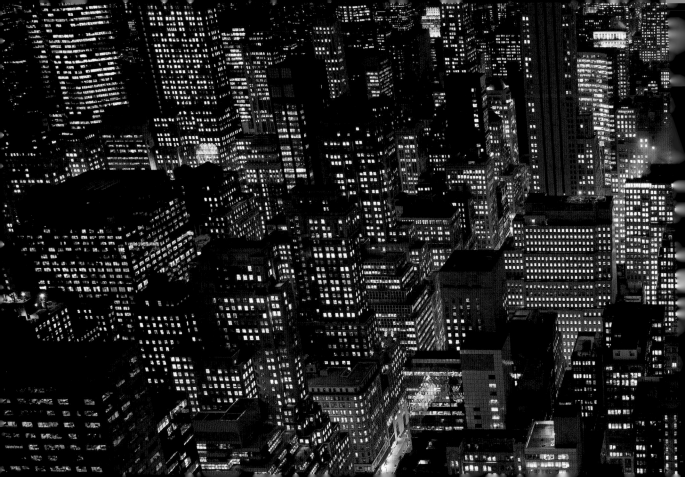

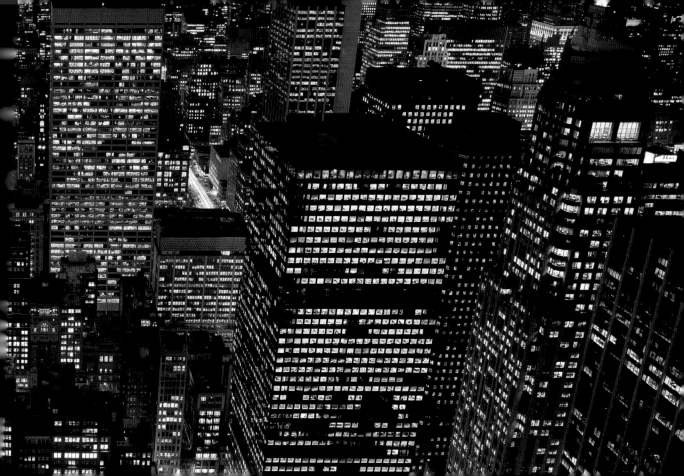

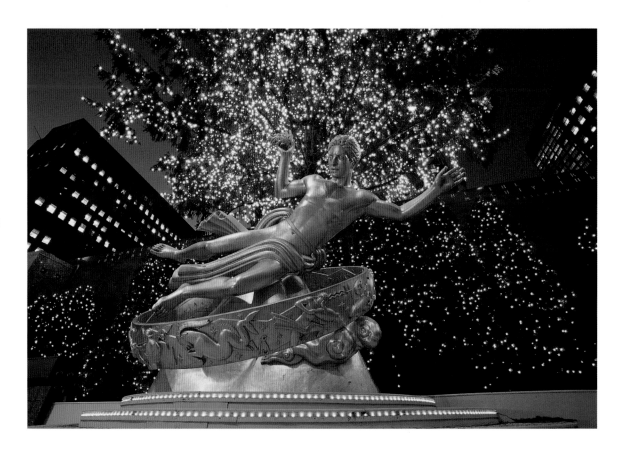

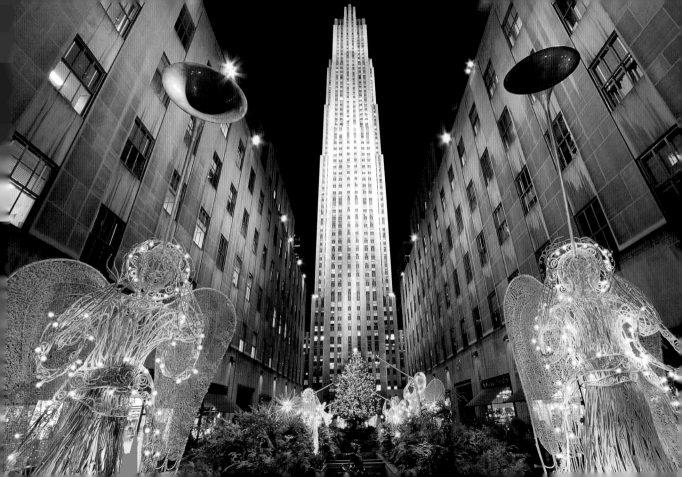

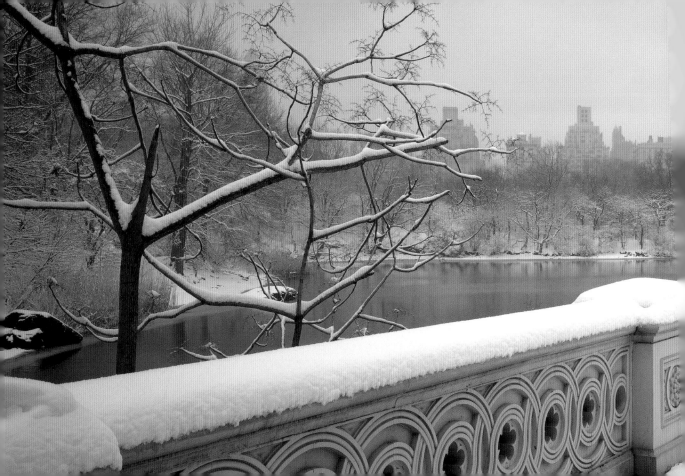

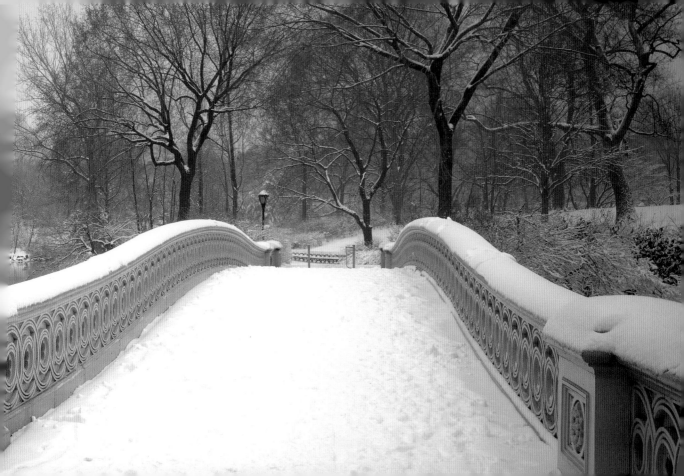

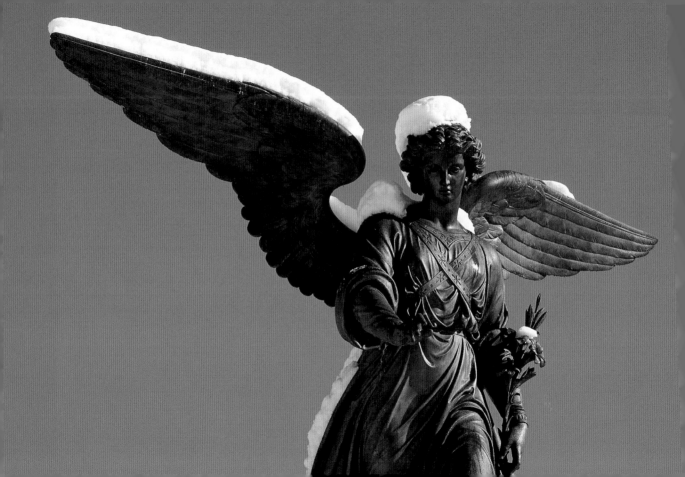

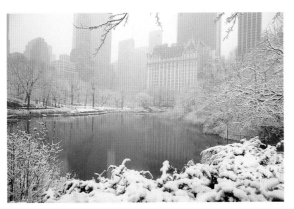
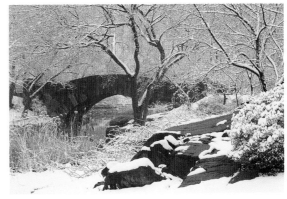

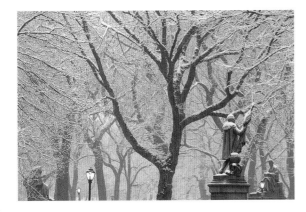
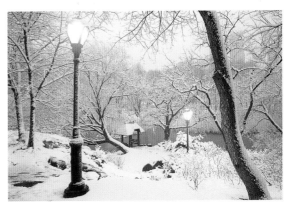

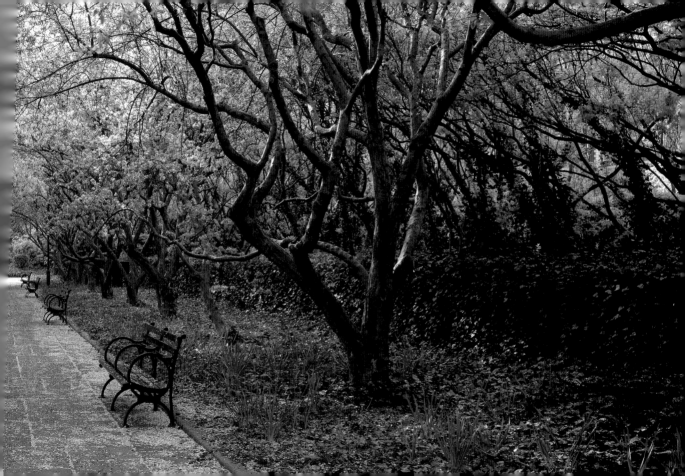

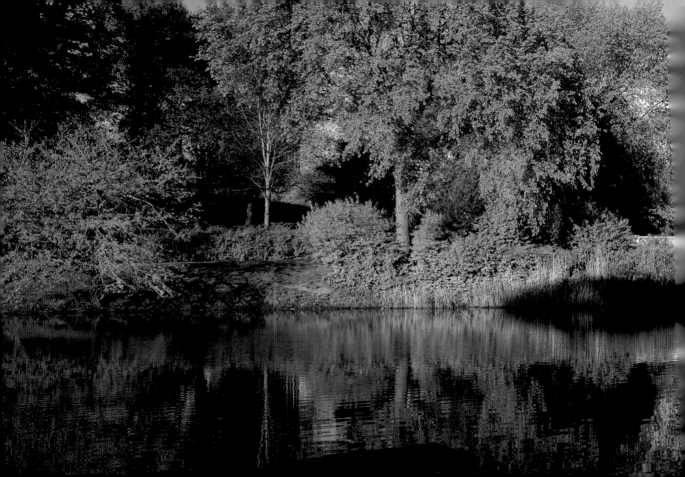

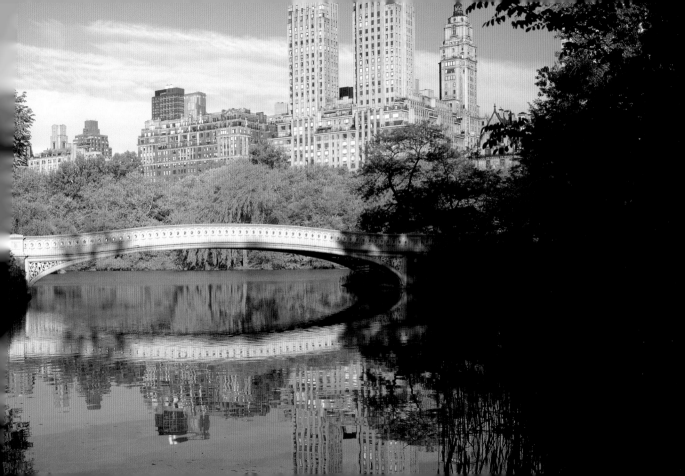

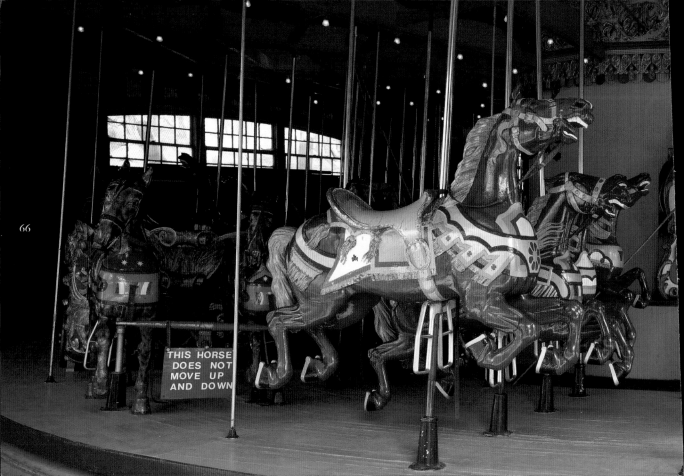

THIS HORSE
DOES NOT
MOVE UP
AND DOWN

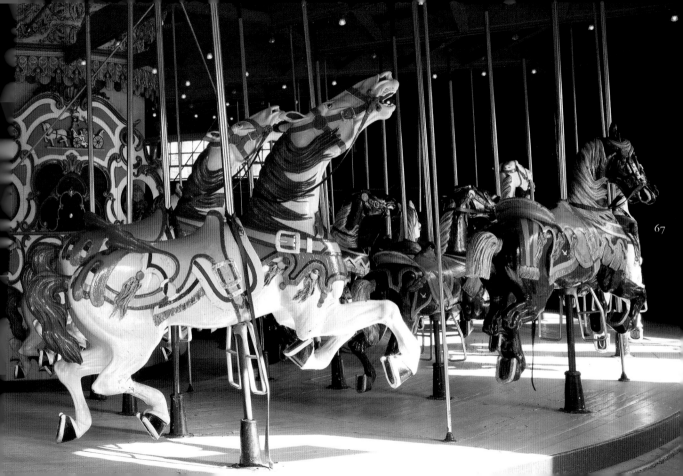

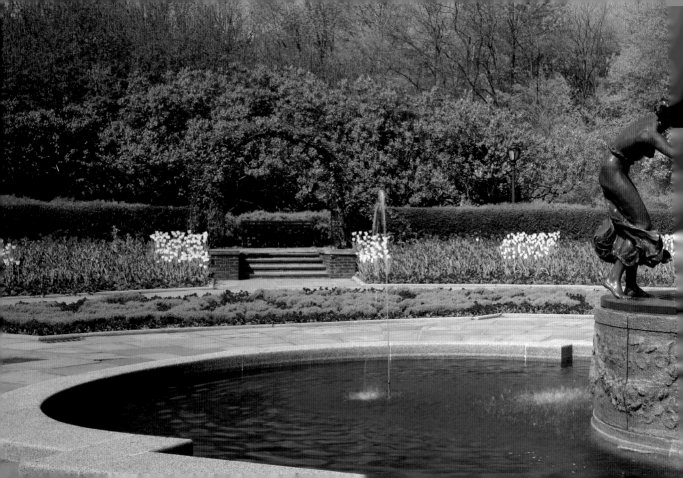

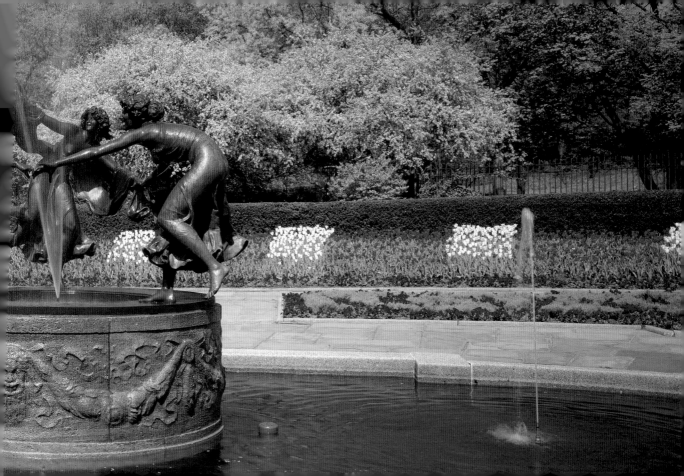

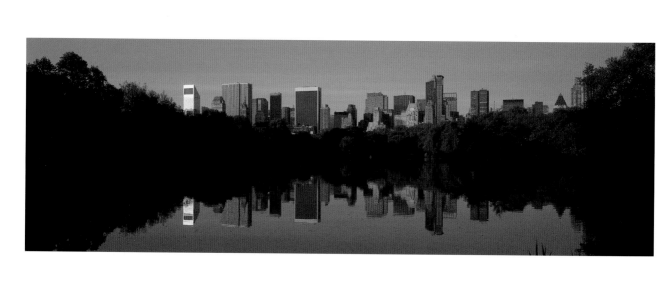

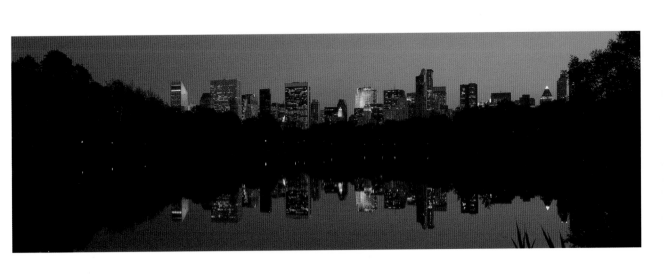

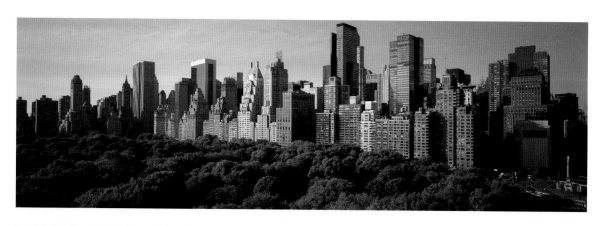

72

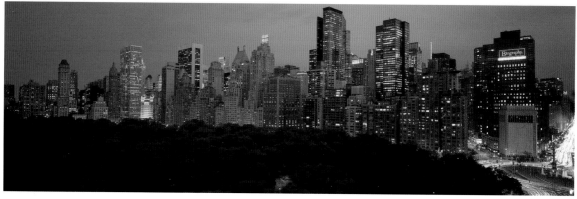

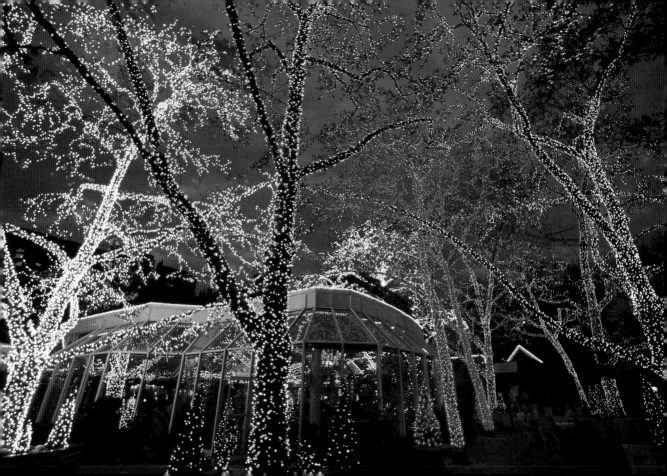

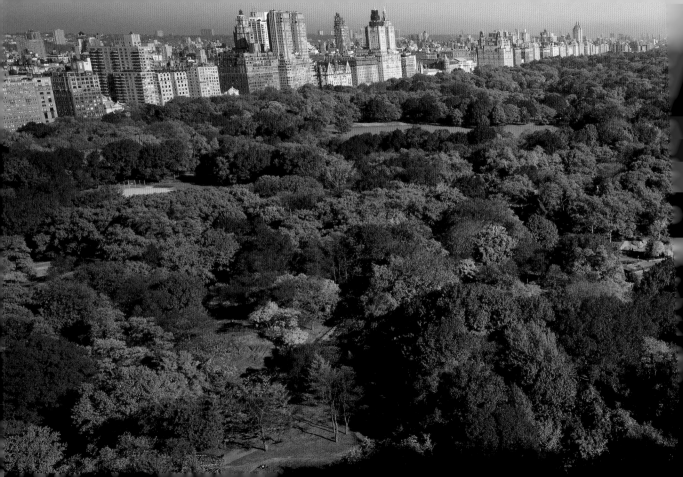

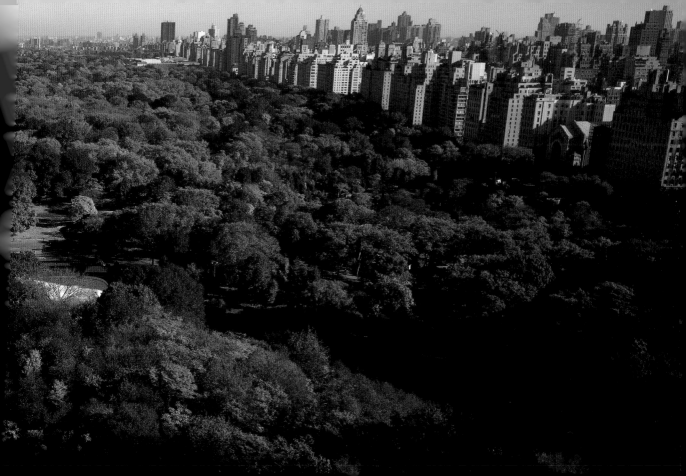

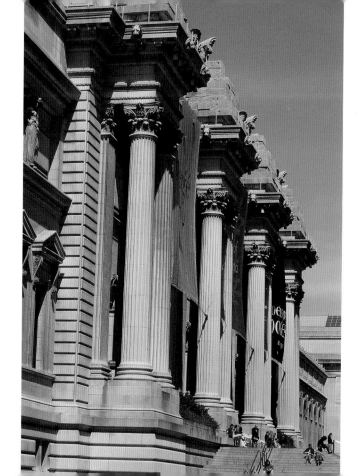

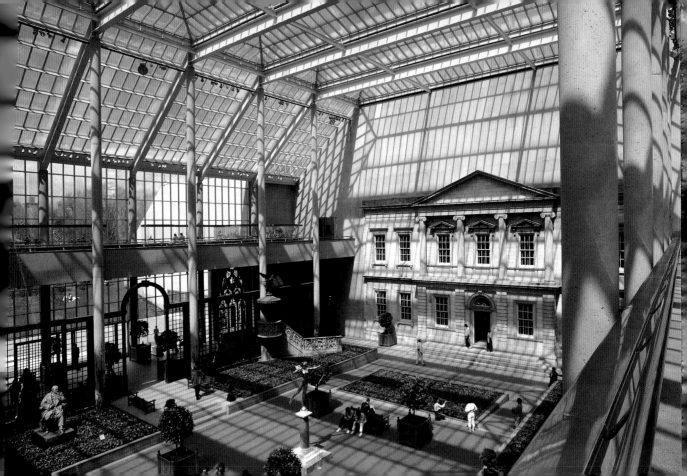

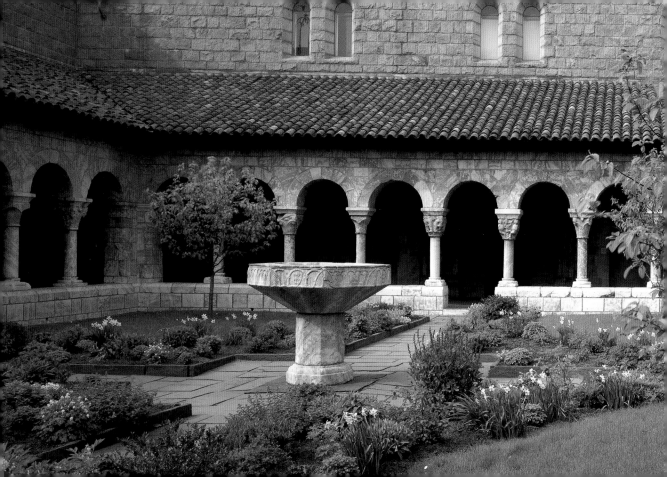

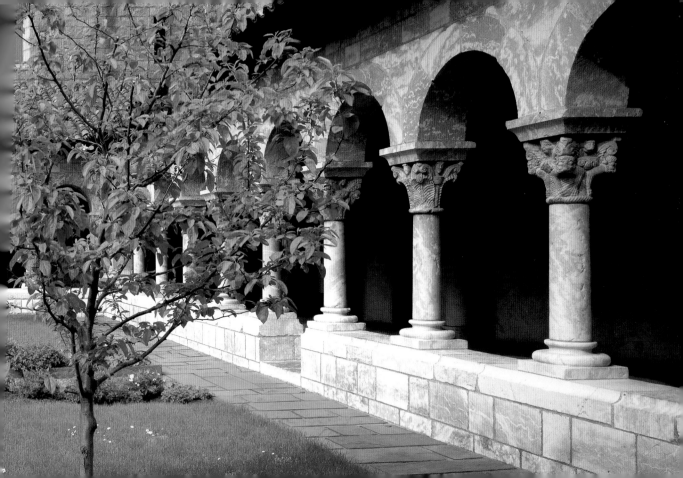

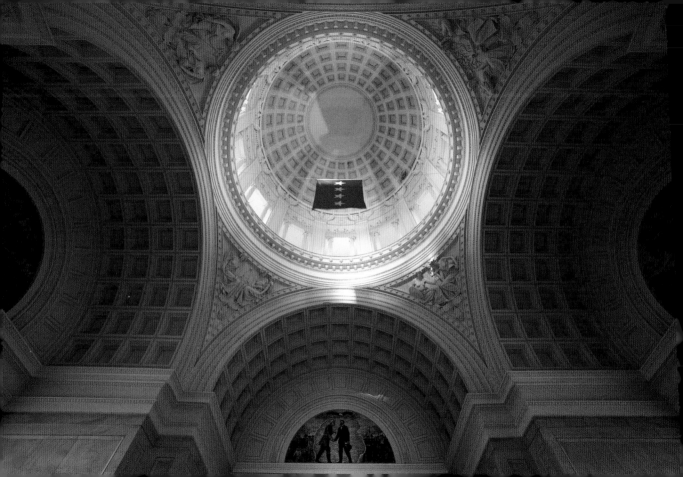

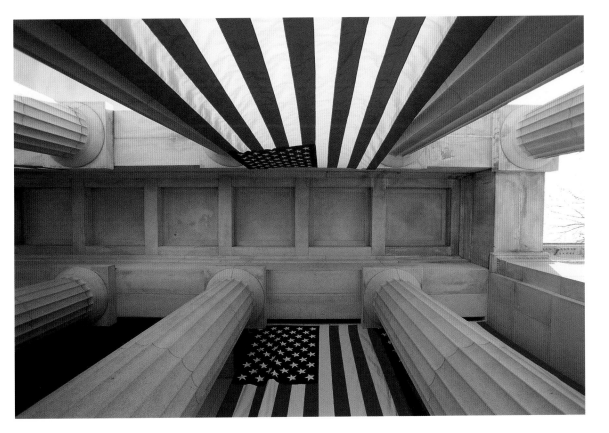

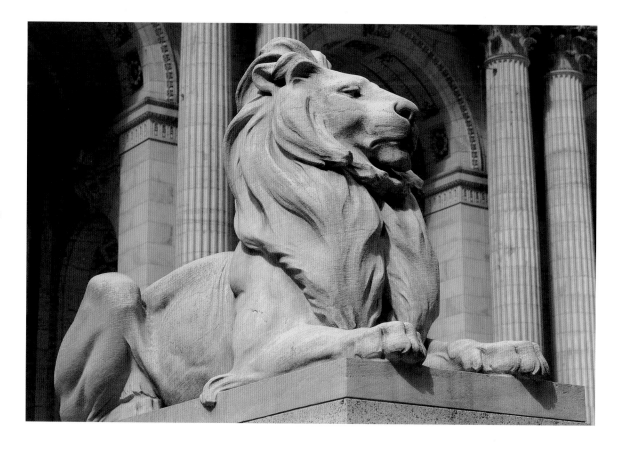

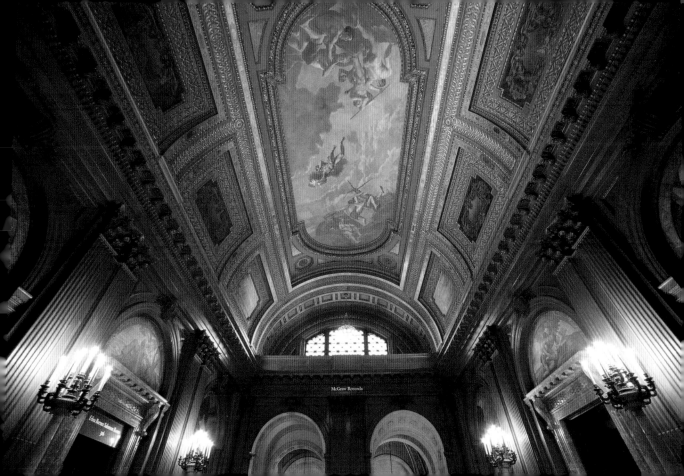

McGraw Rotunda

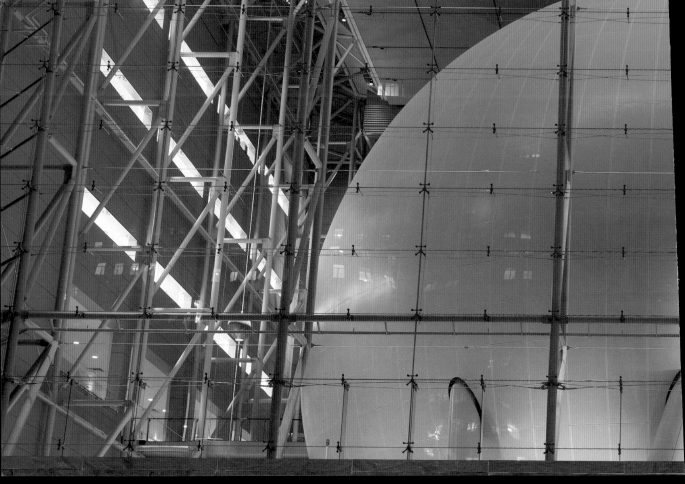

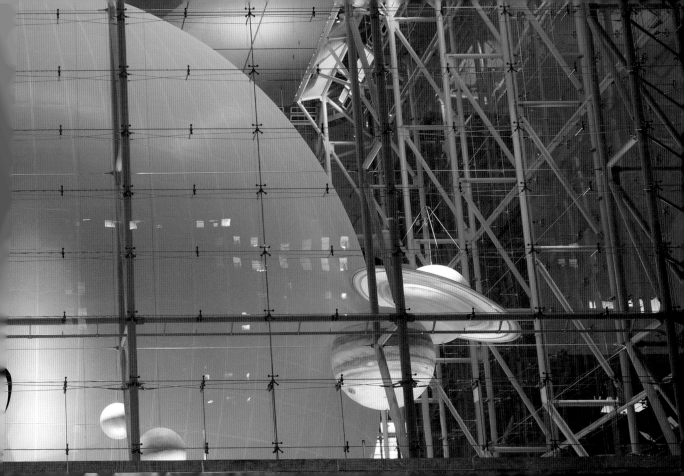

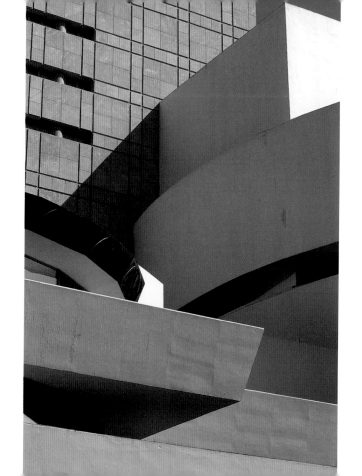

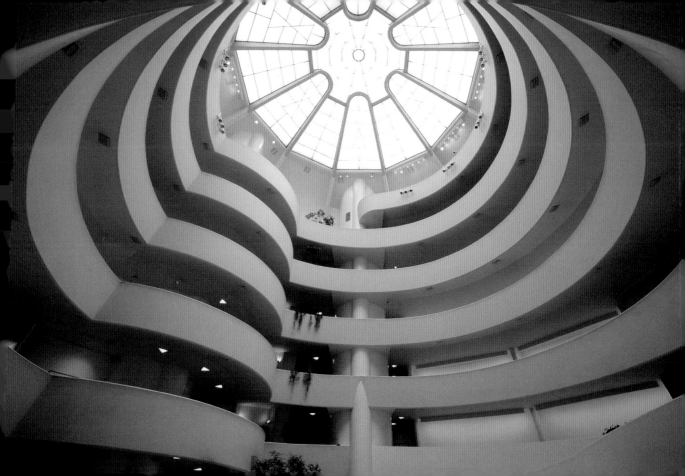

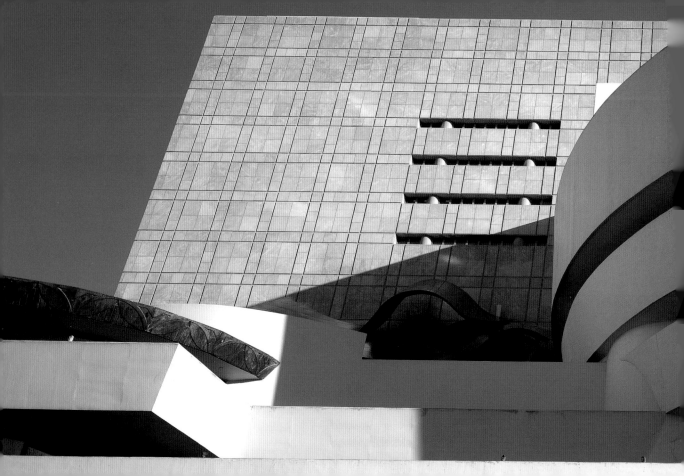

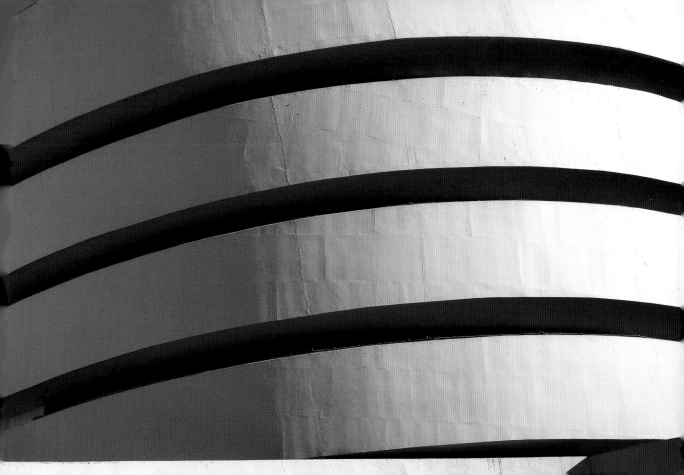

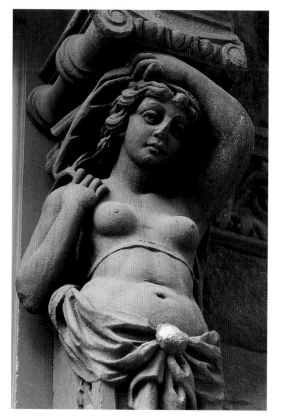

94

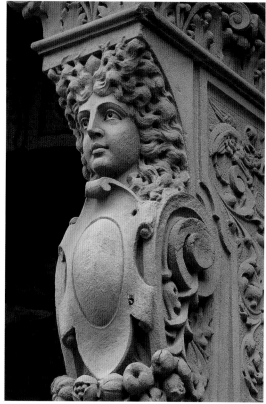

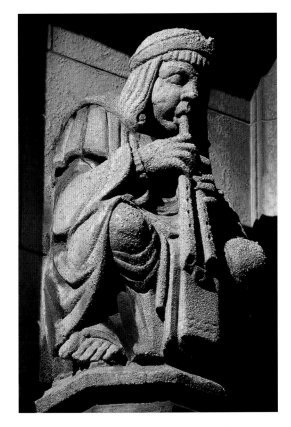
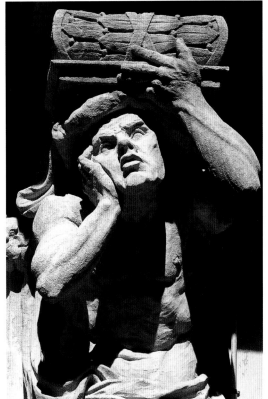

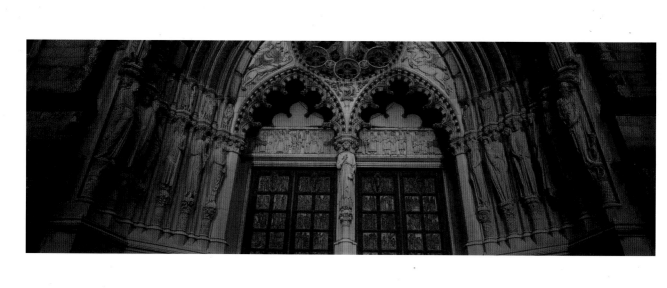

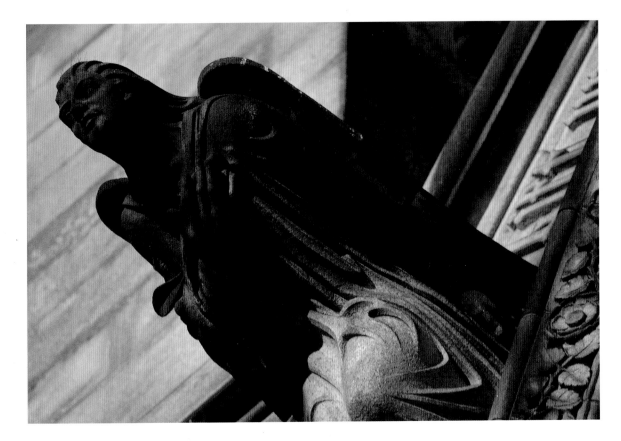

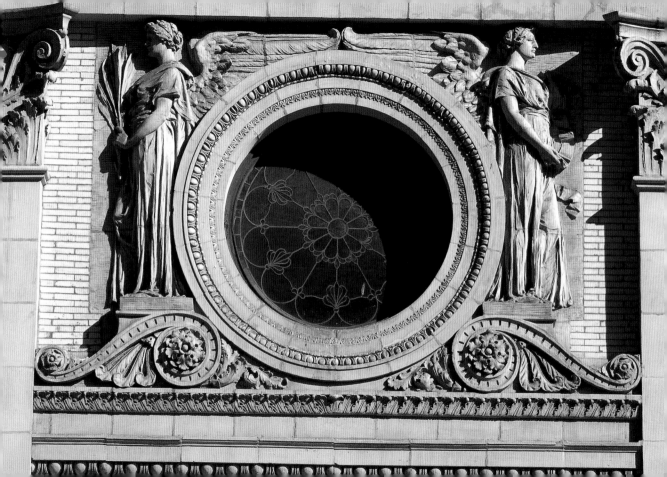

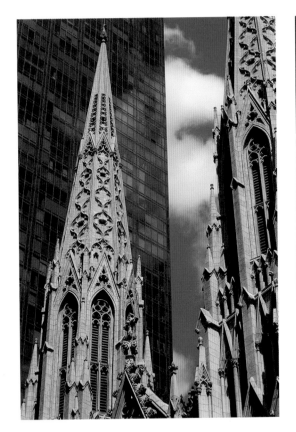

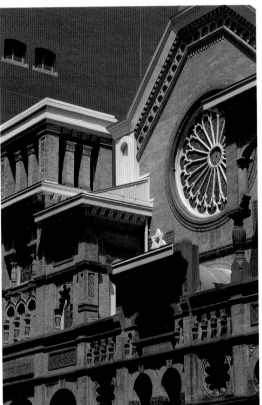

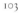

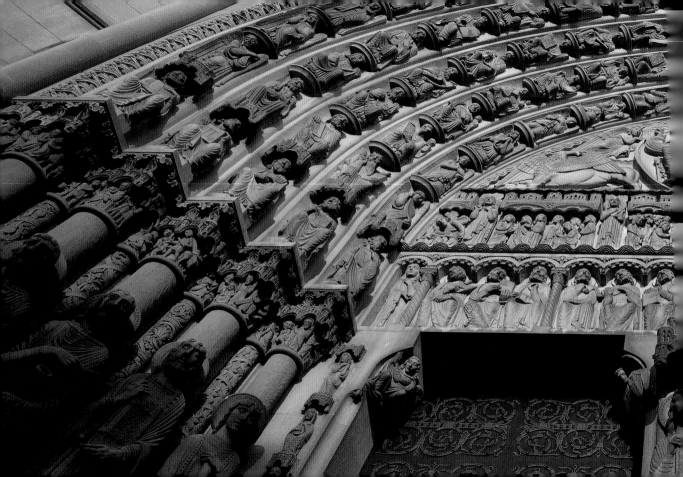

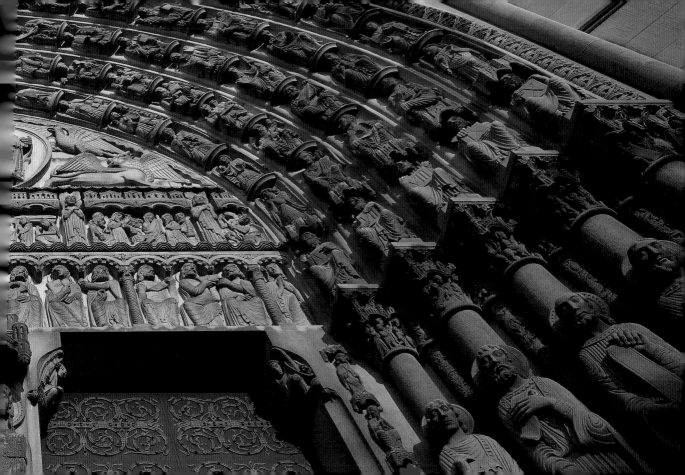

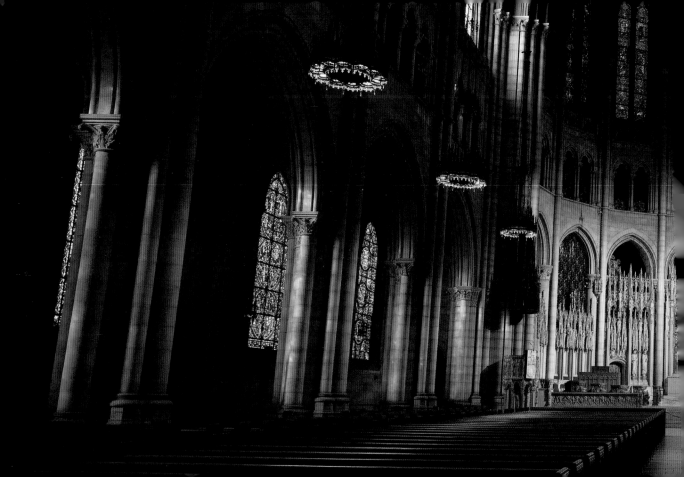

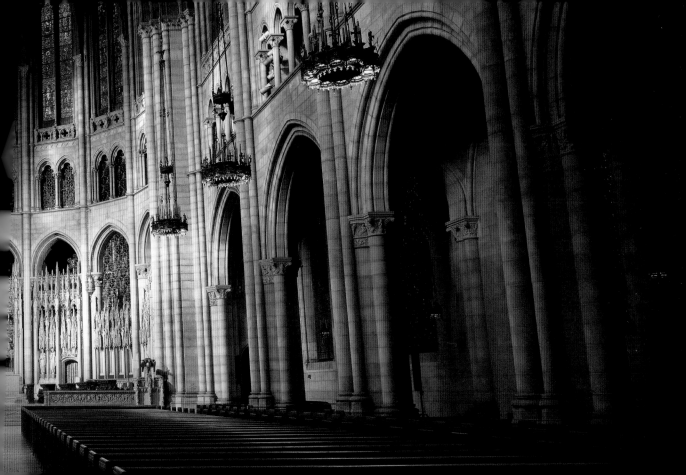

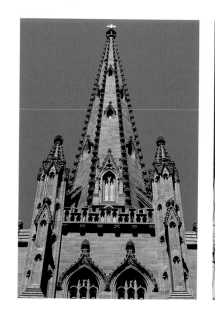
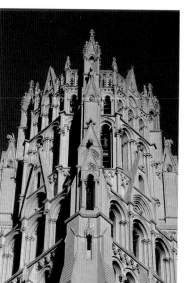
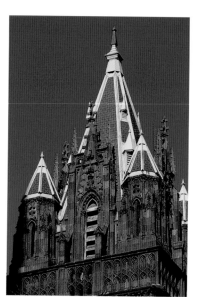

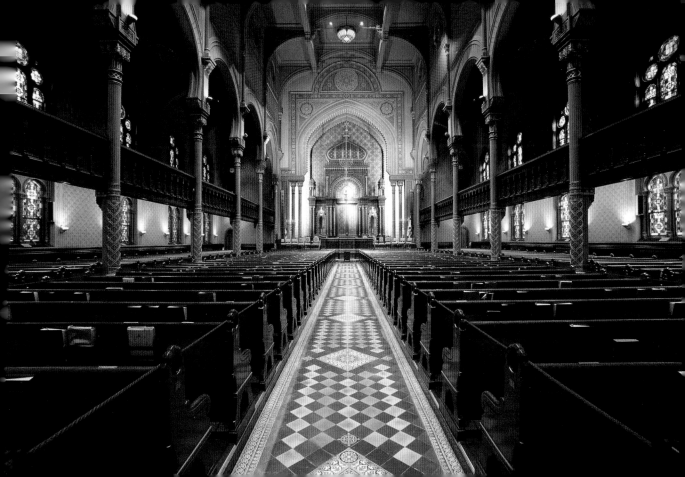

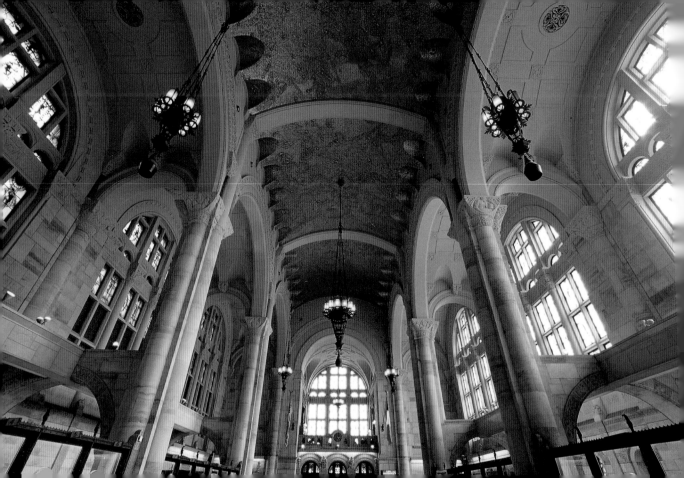

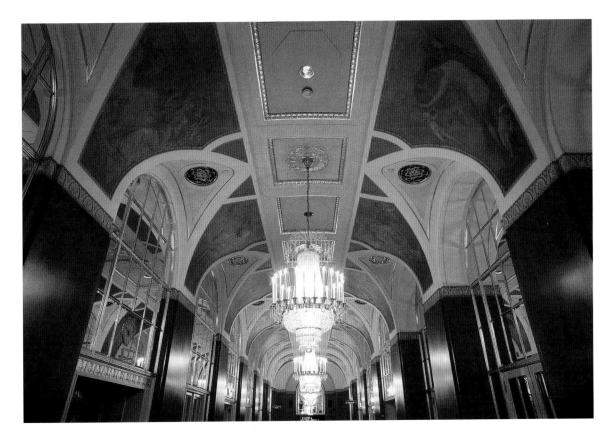

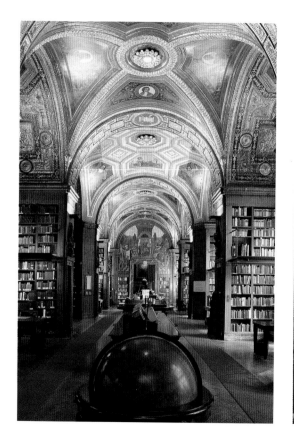
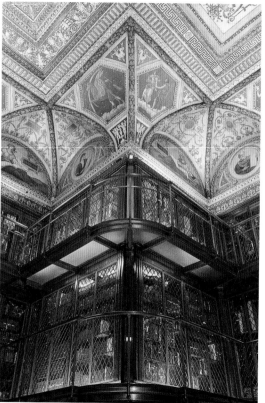

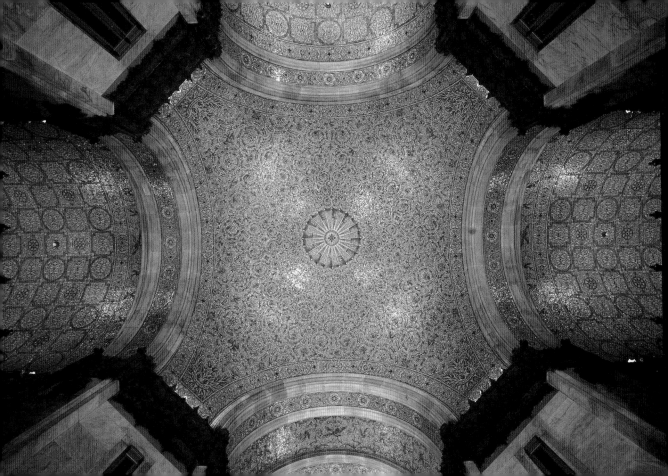

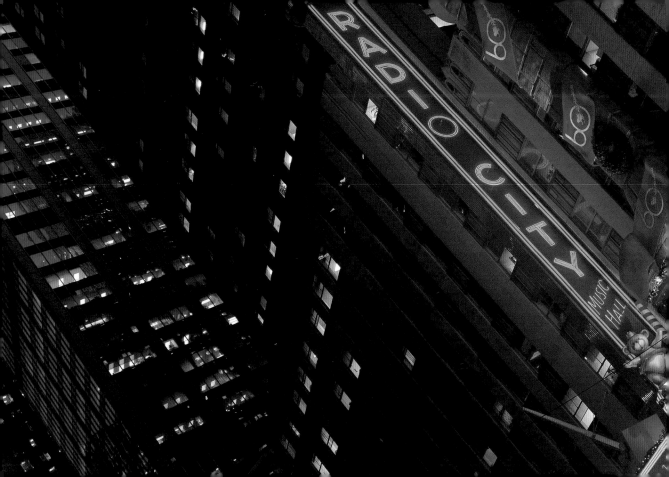

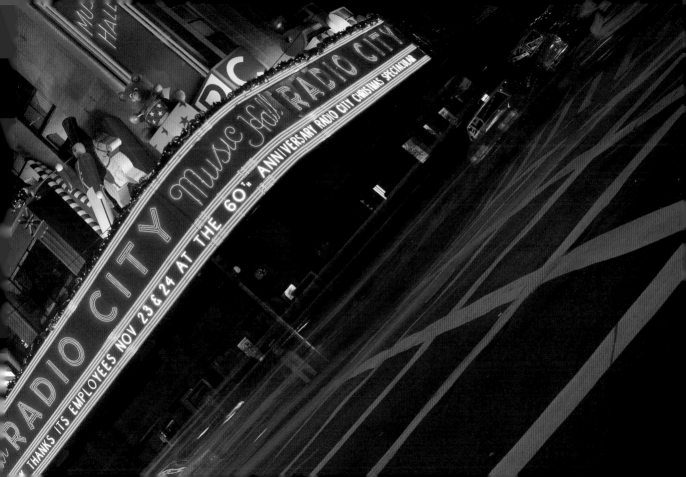

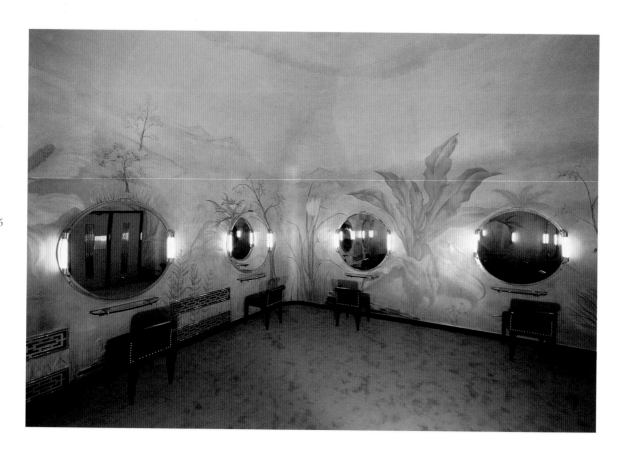

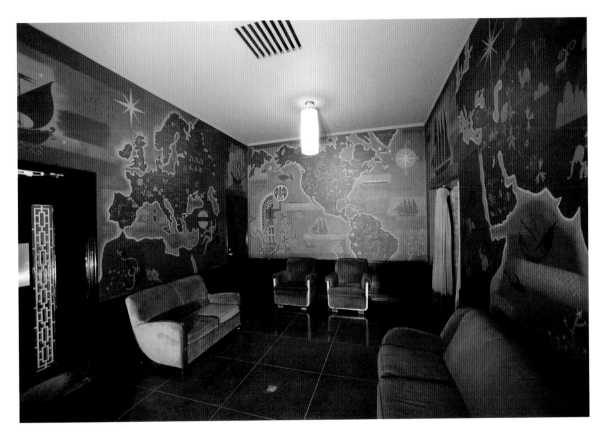

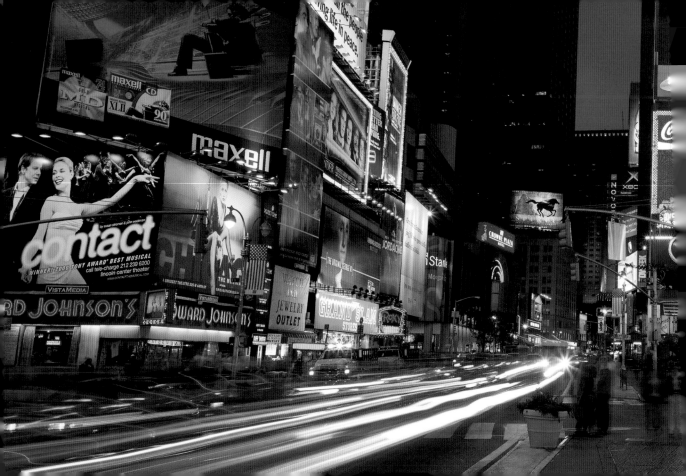

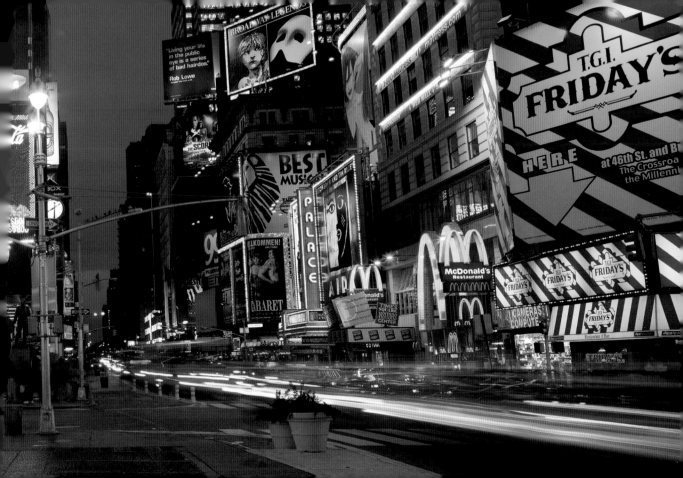

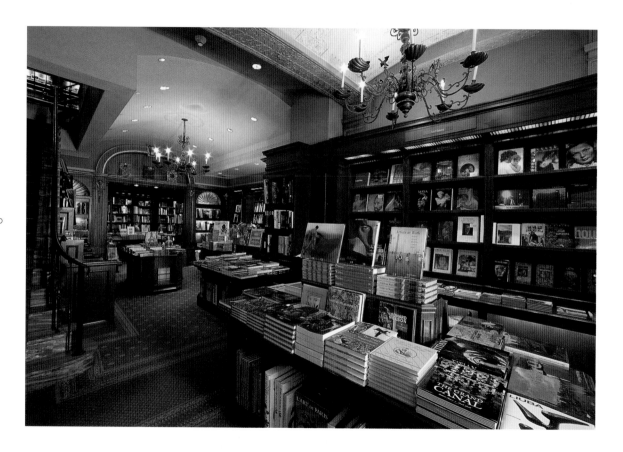

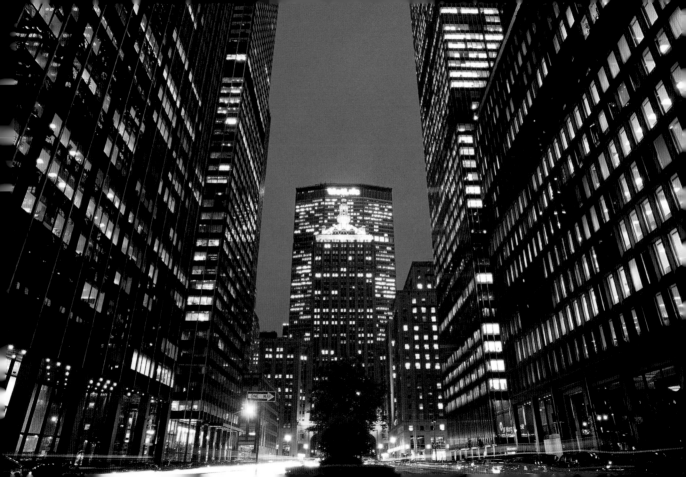

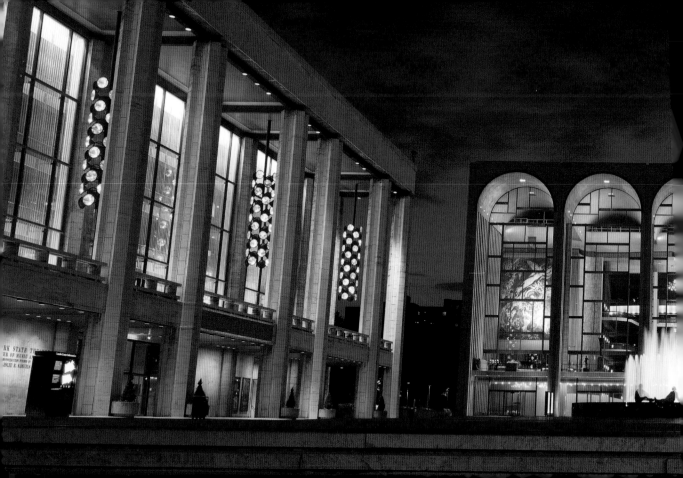

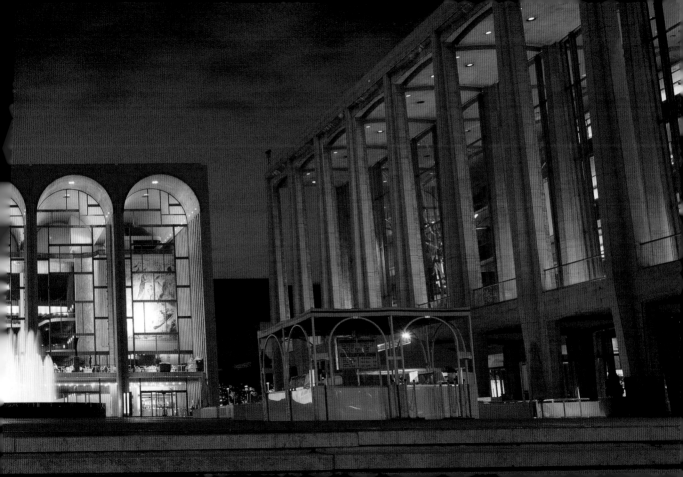

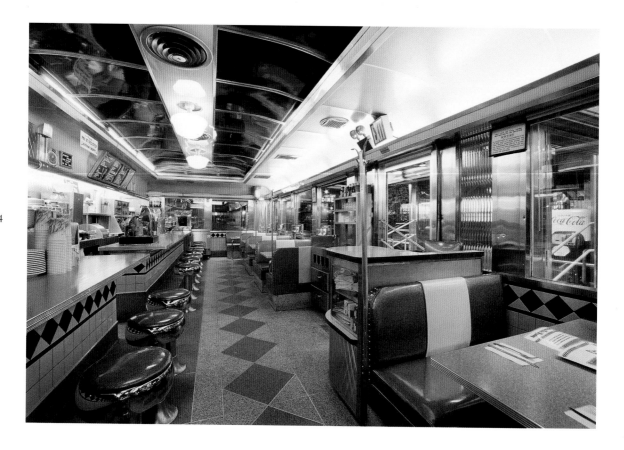

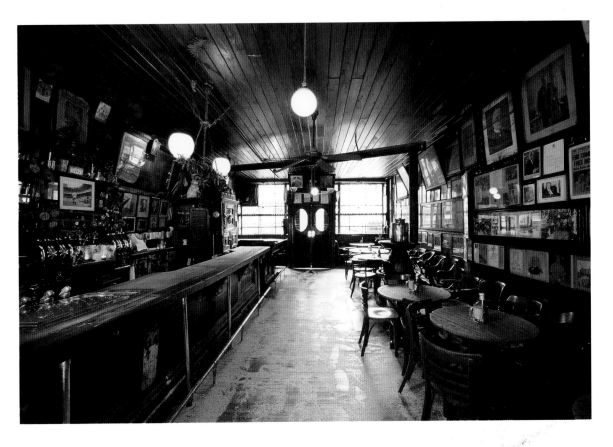

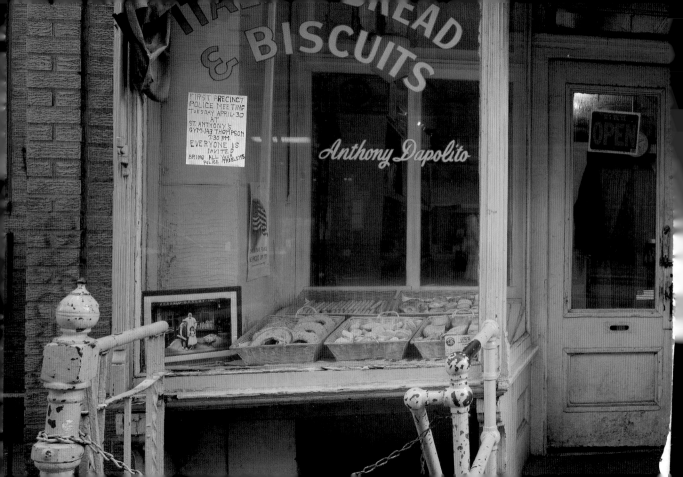

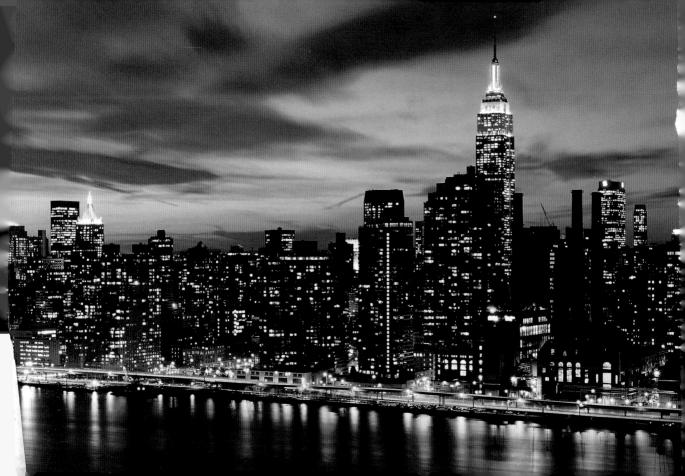

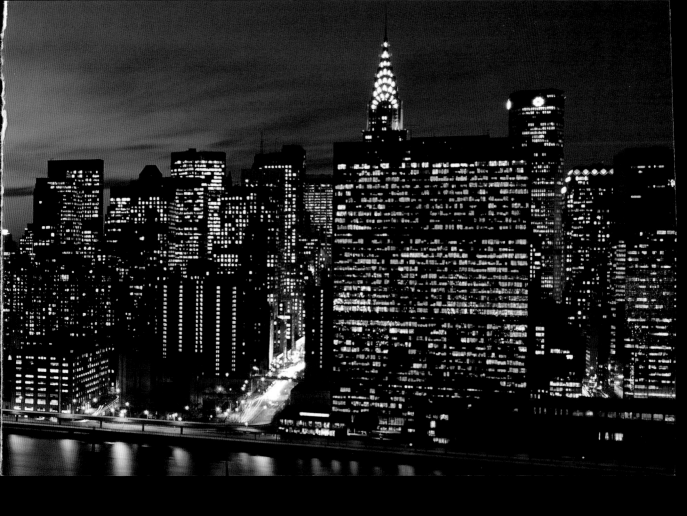

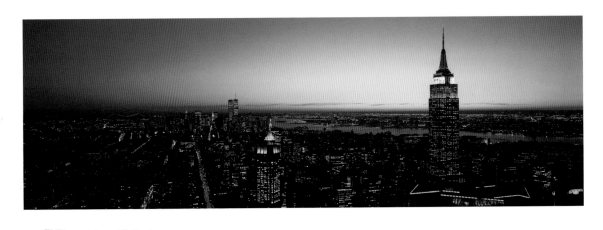

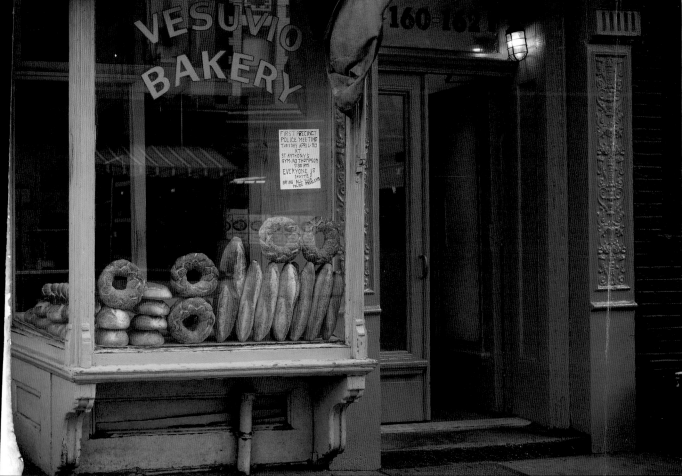

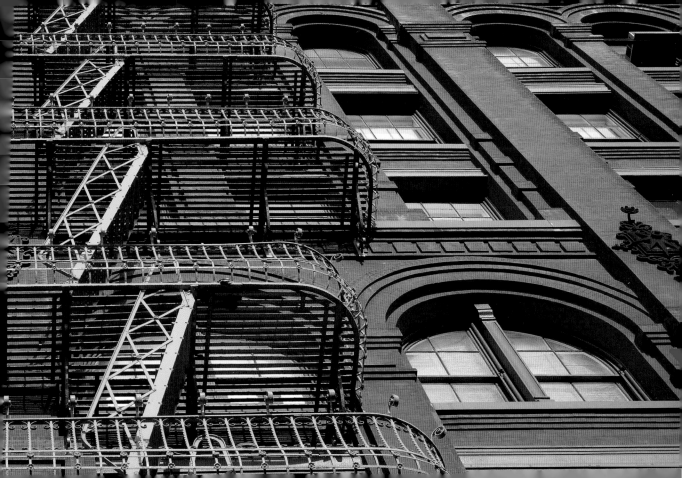

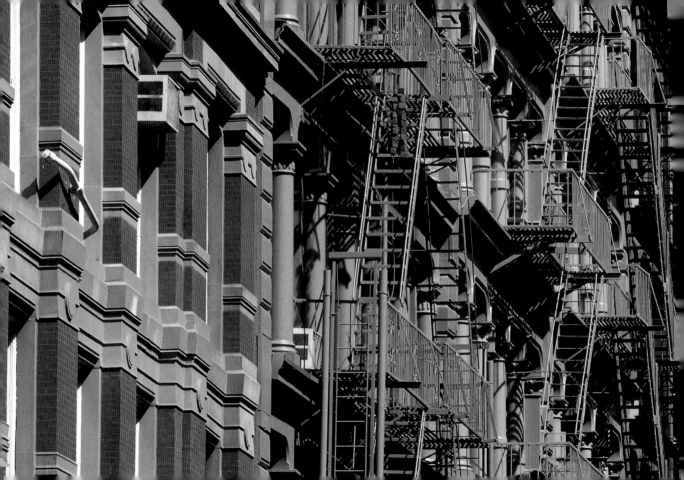

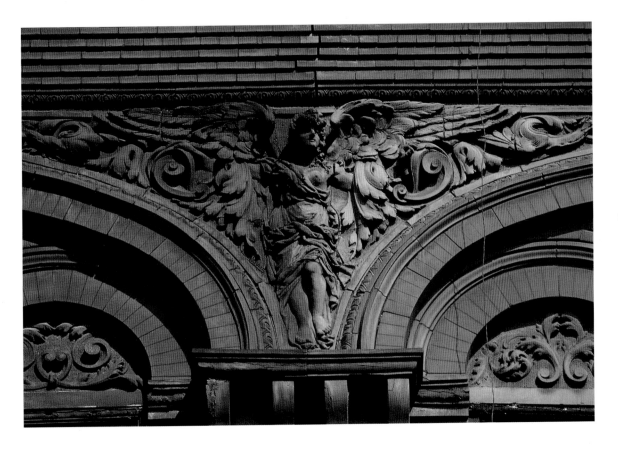

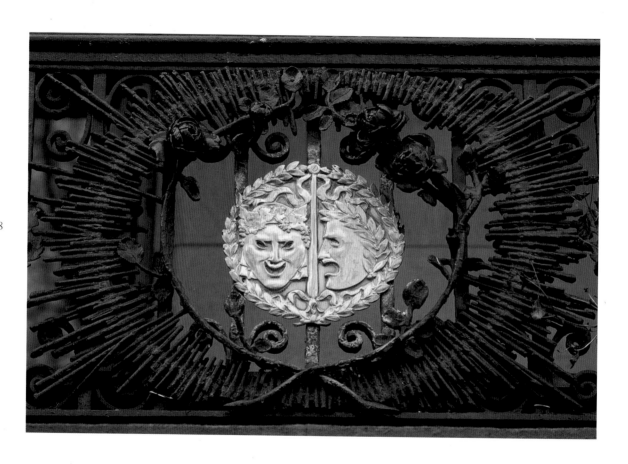

138

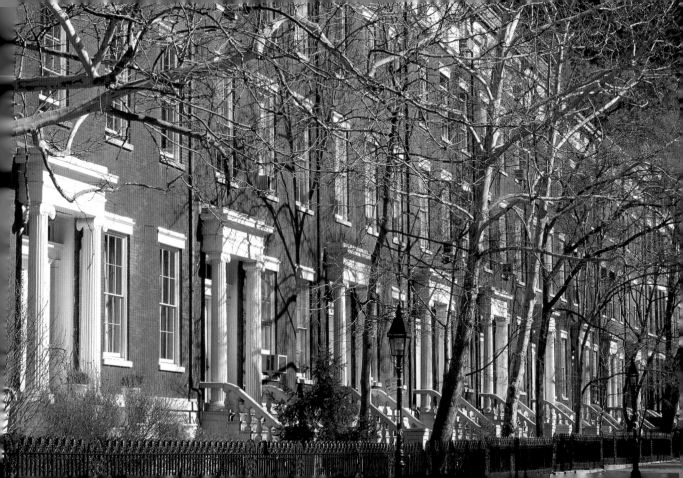

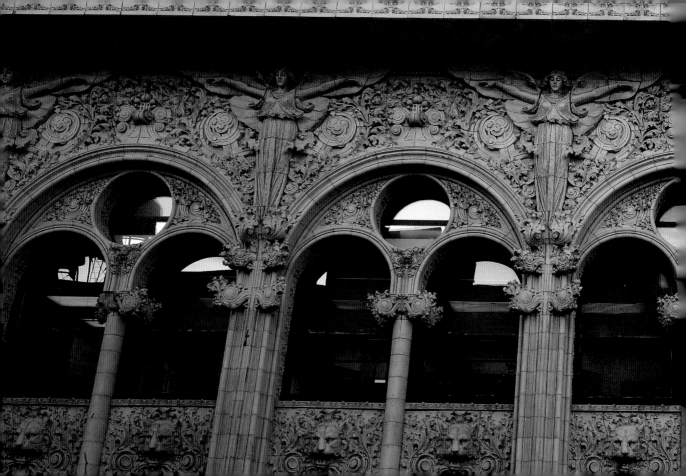

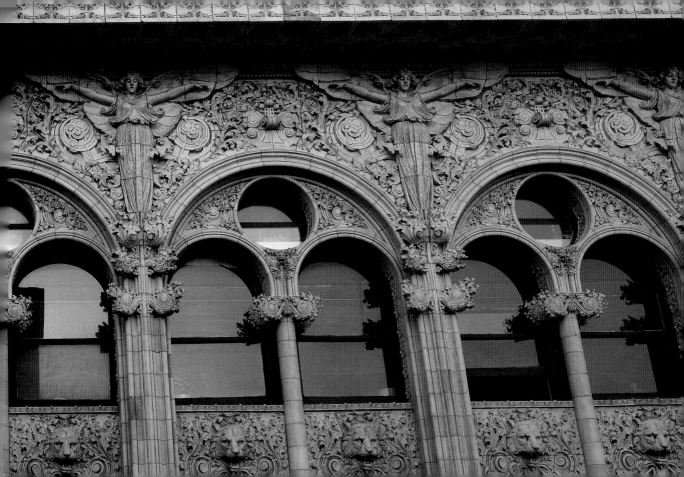

142

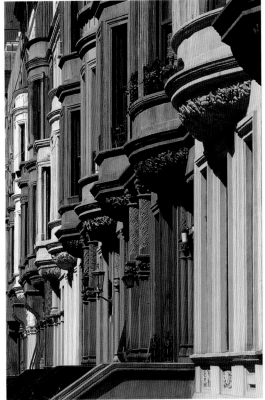

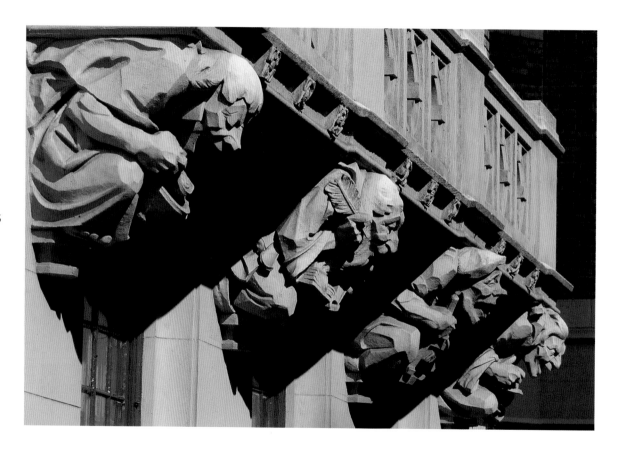

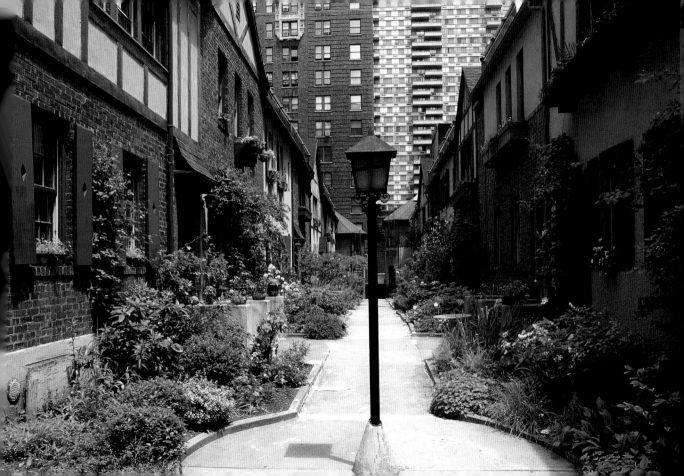

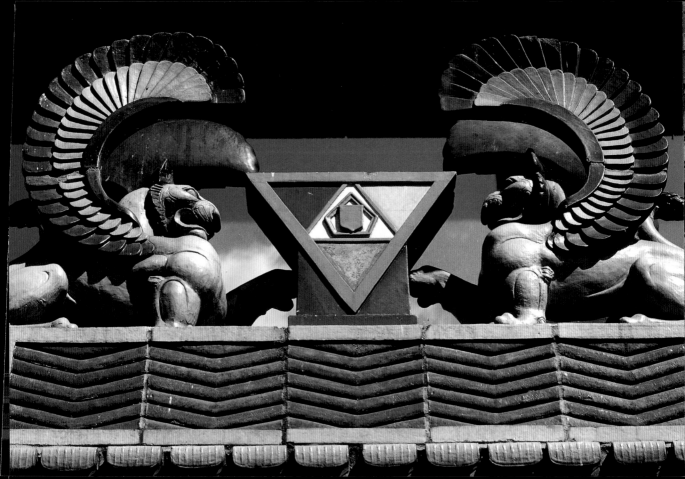

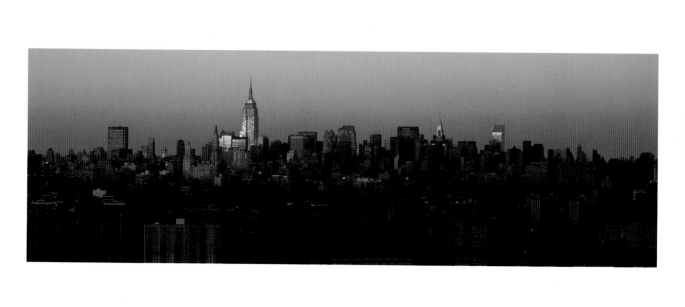

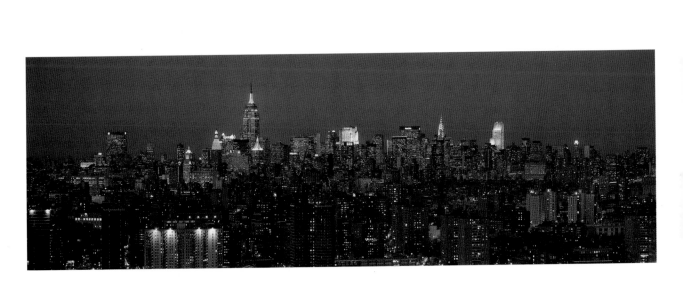

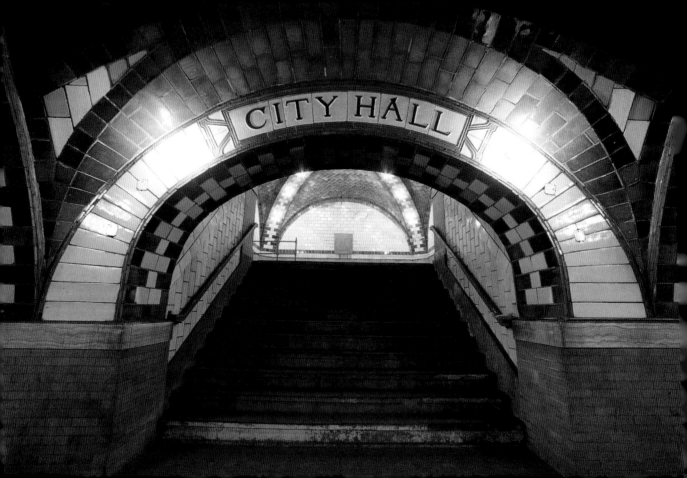

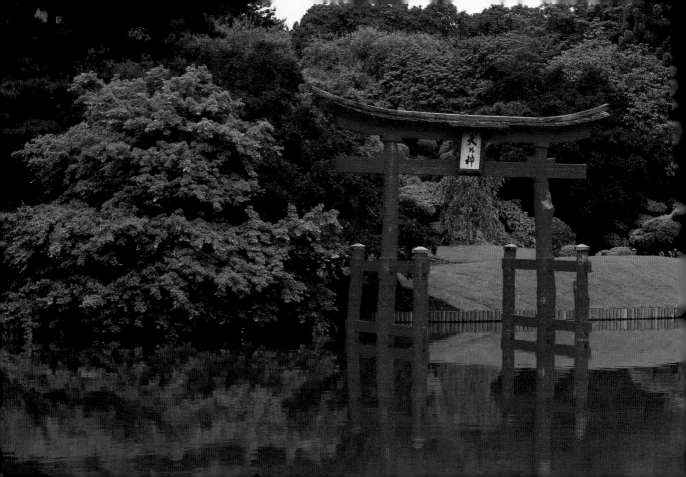

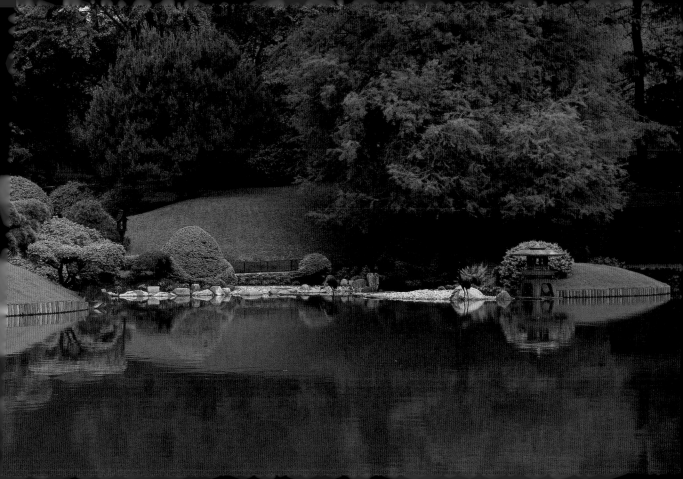

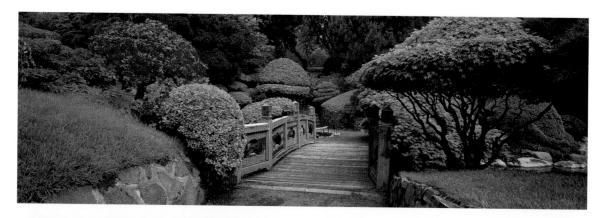

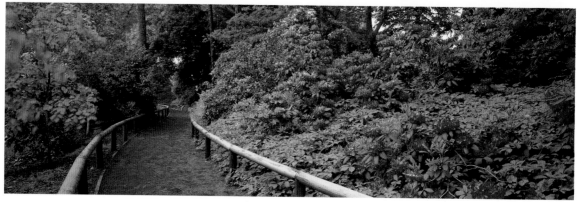

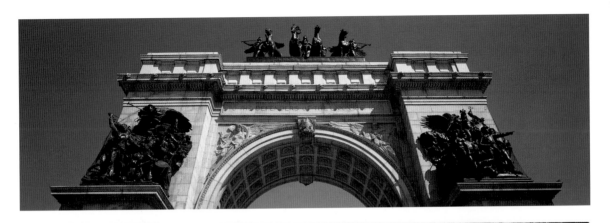

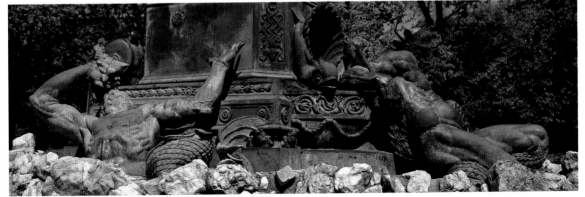

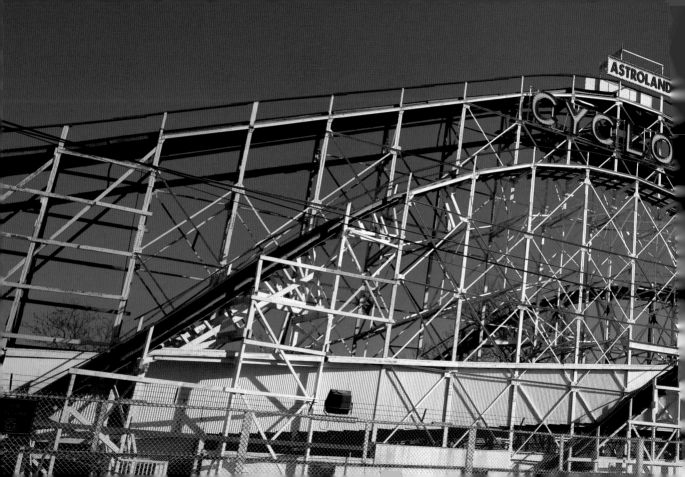

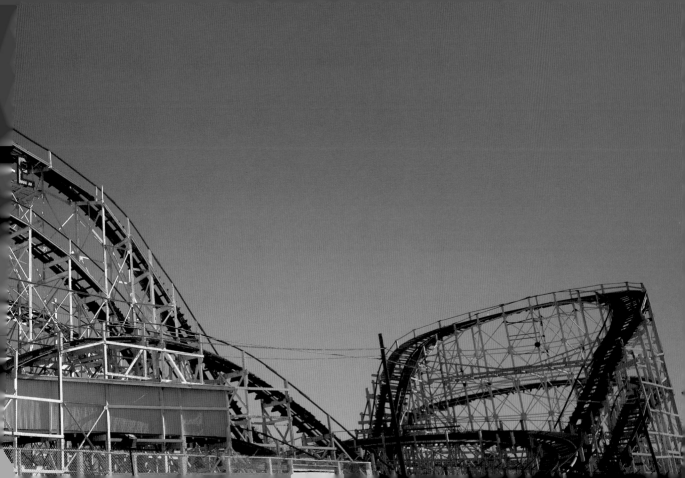

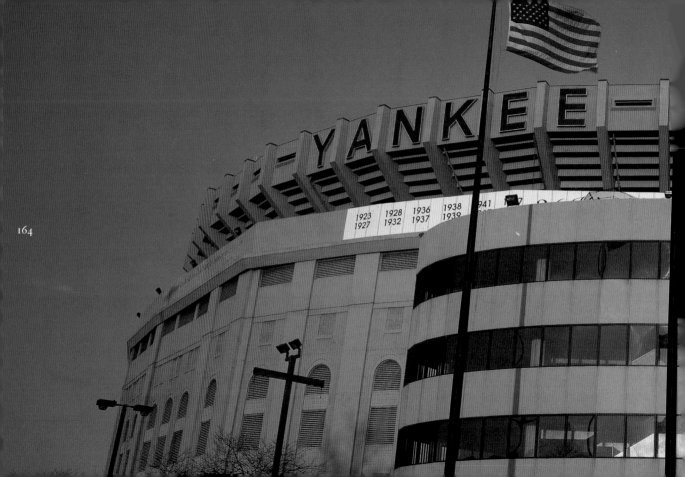

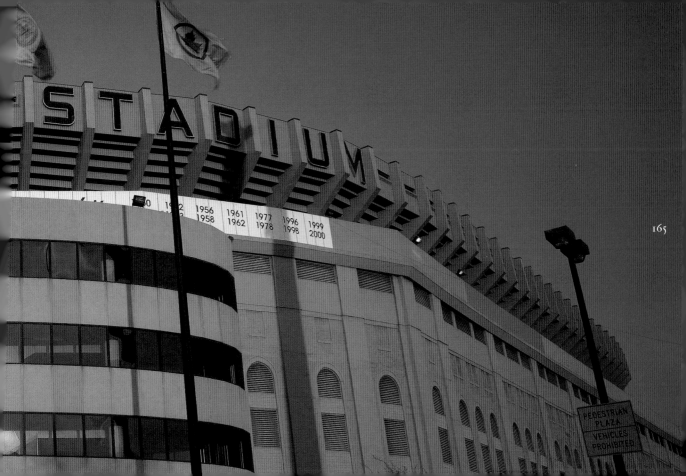

165

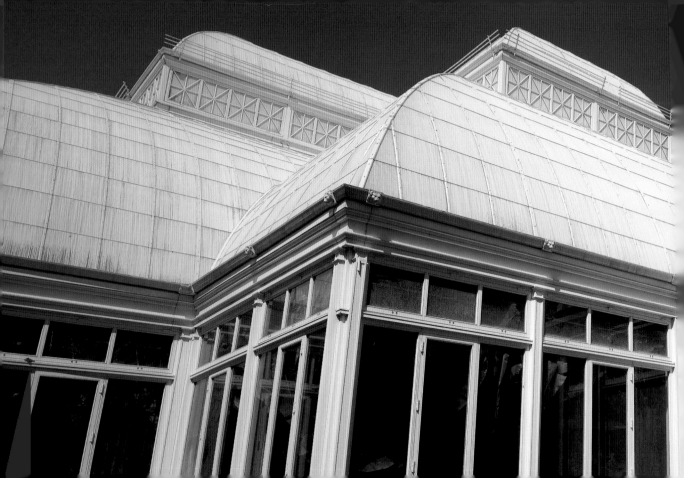

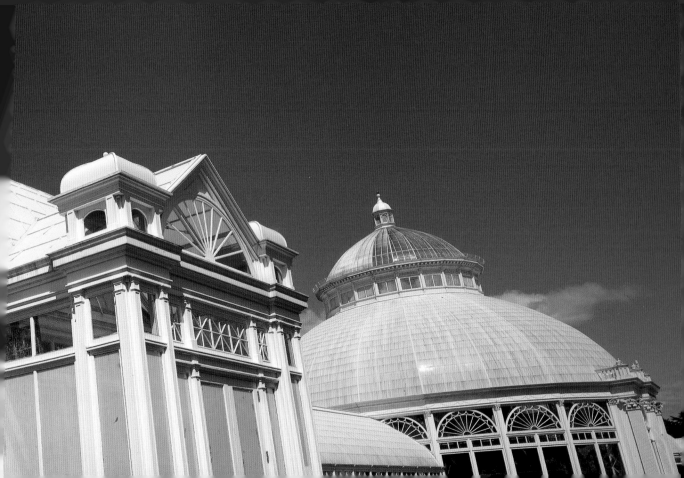

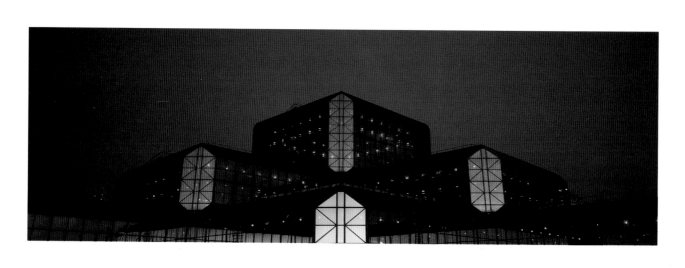

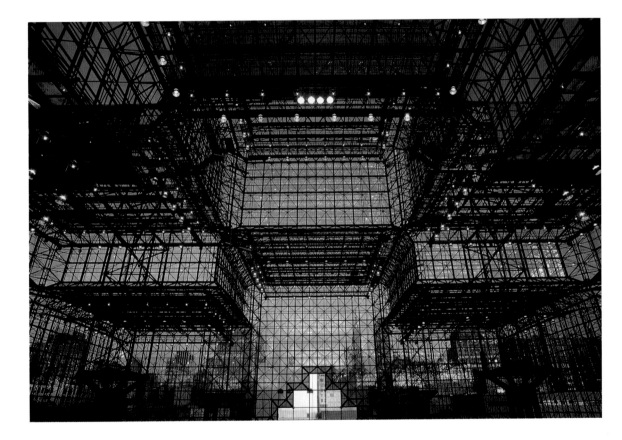

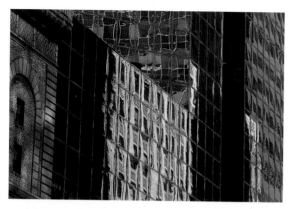
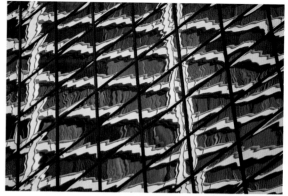
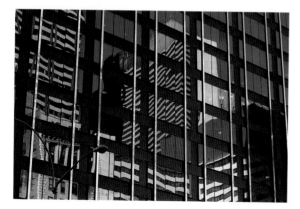
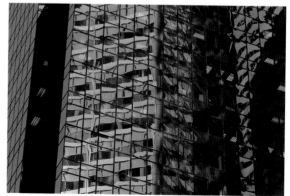

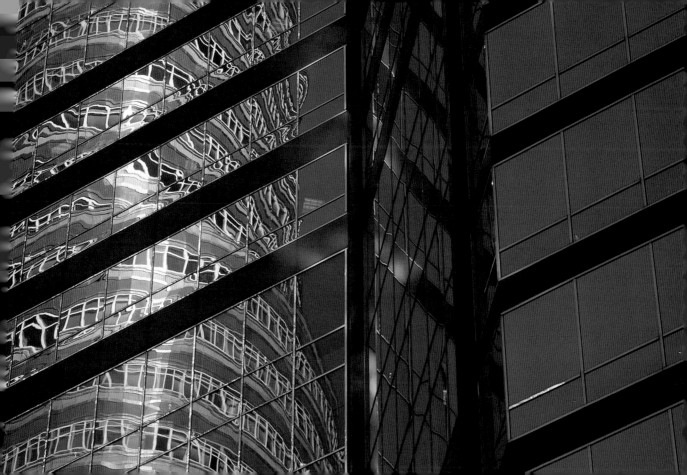

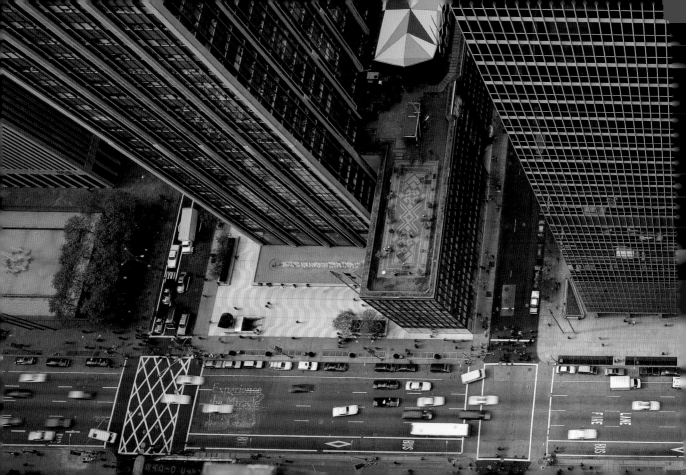

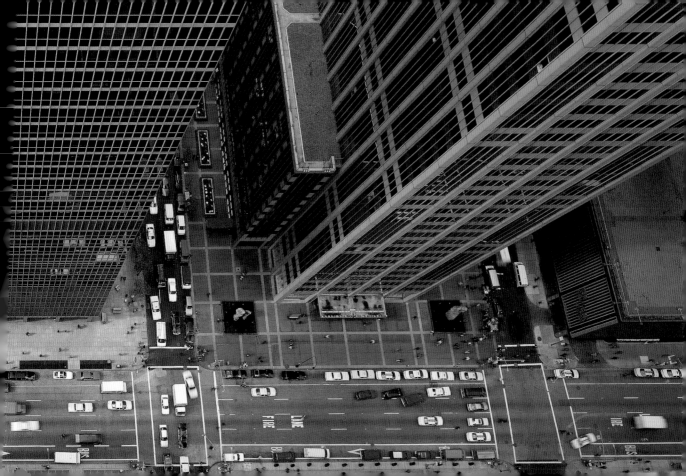

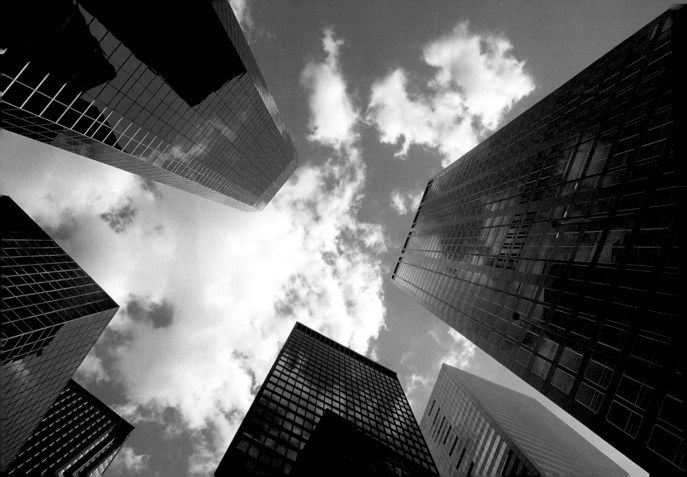

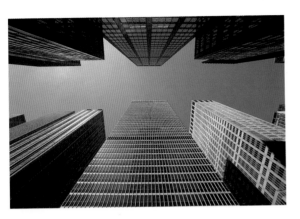
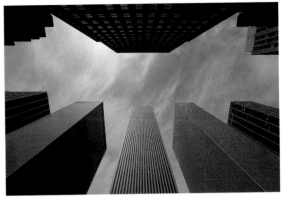

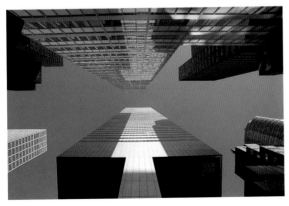
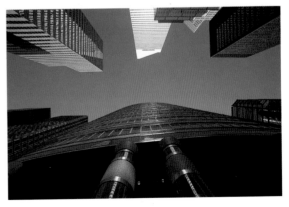

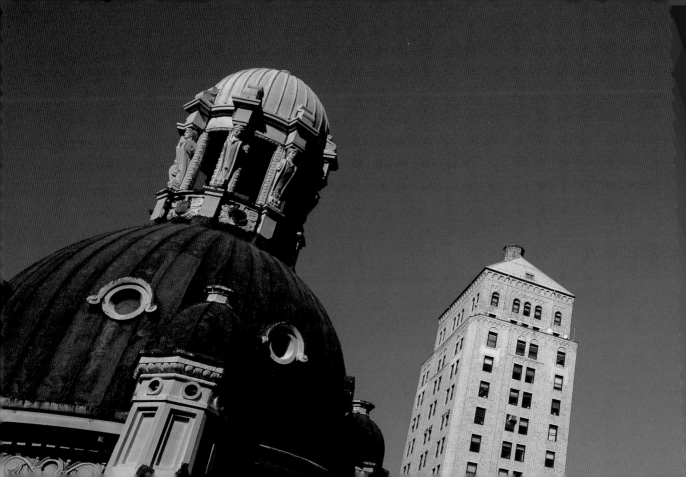

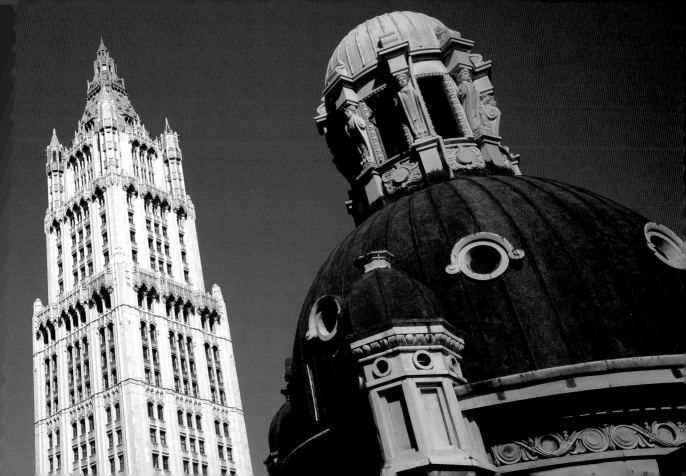

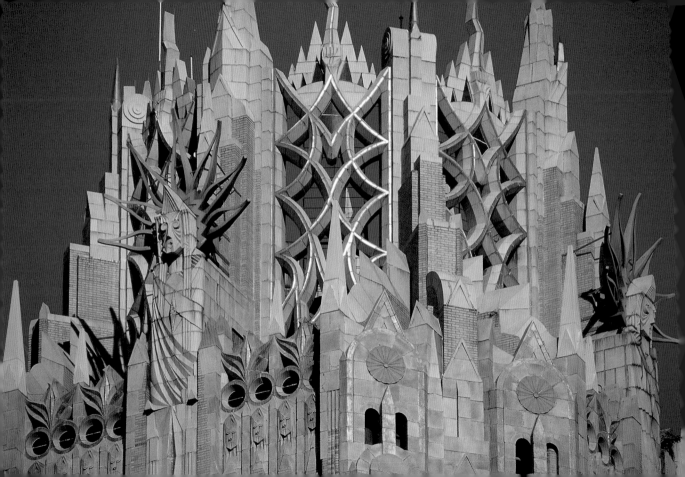

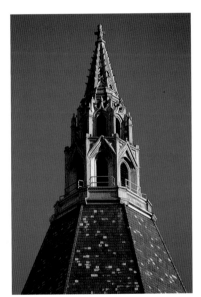
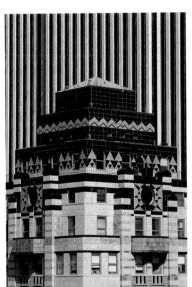
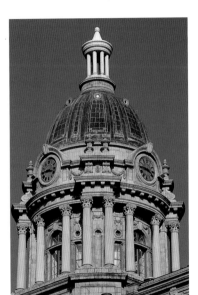

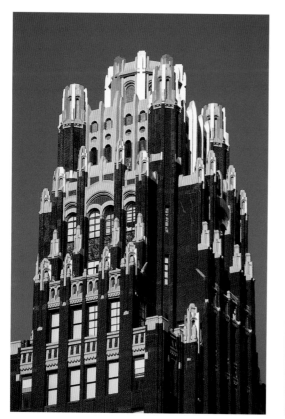

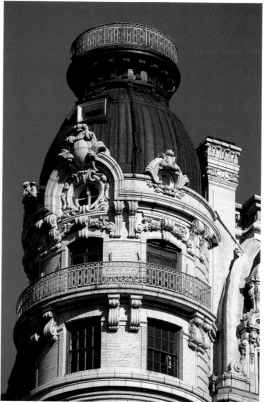

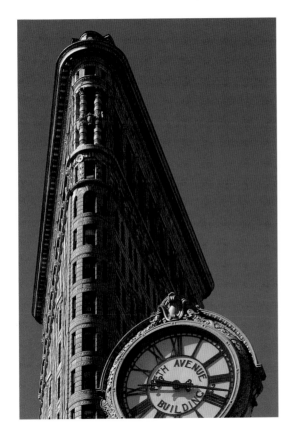

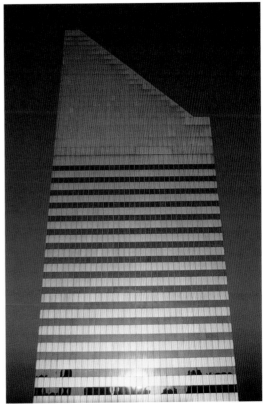

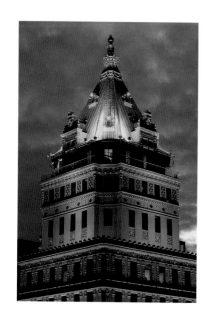
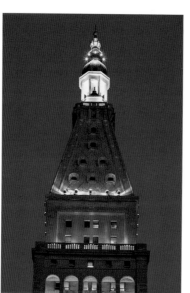
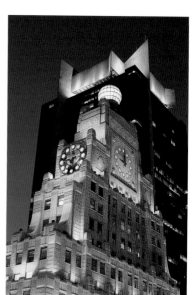

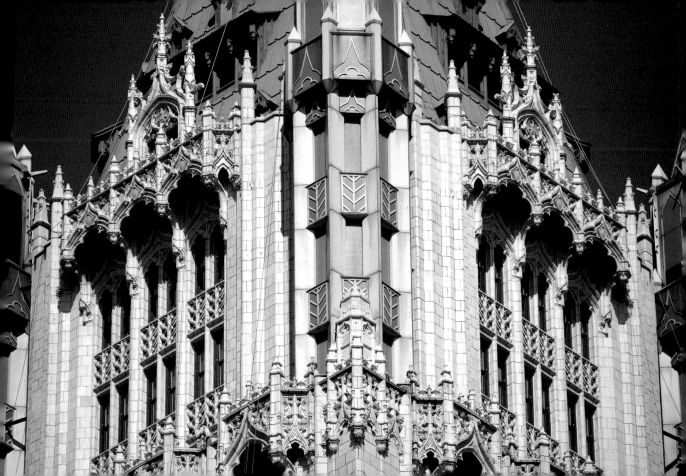

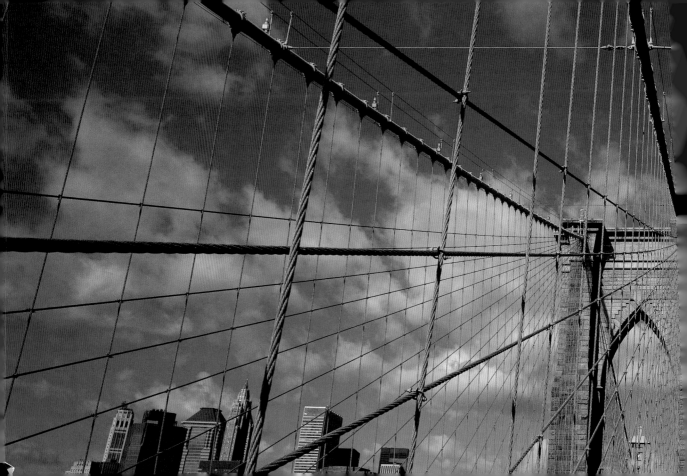

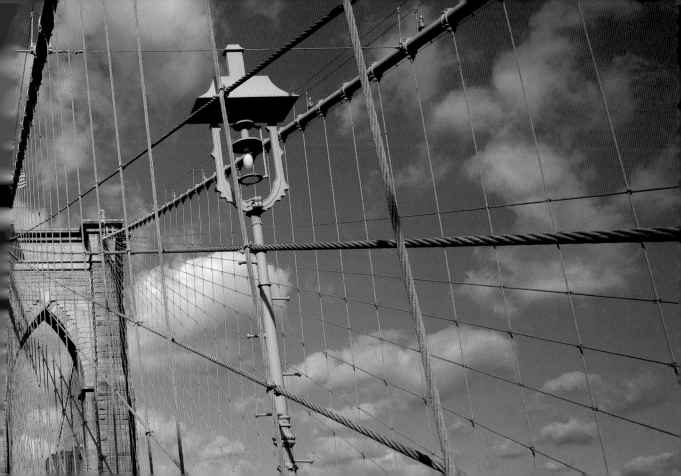

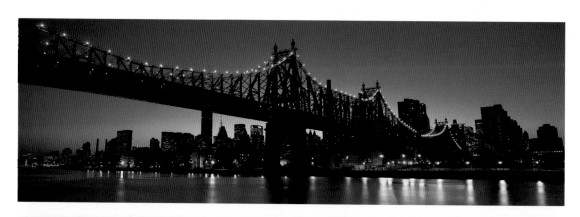

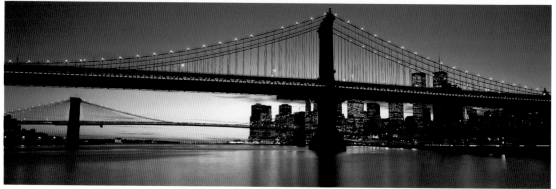

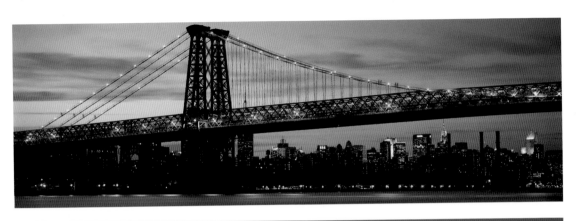

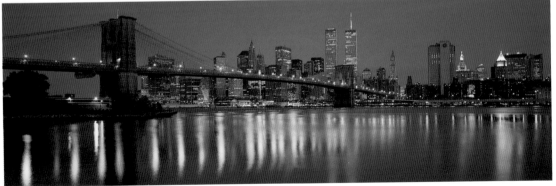

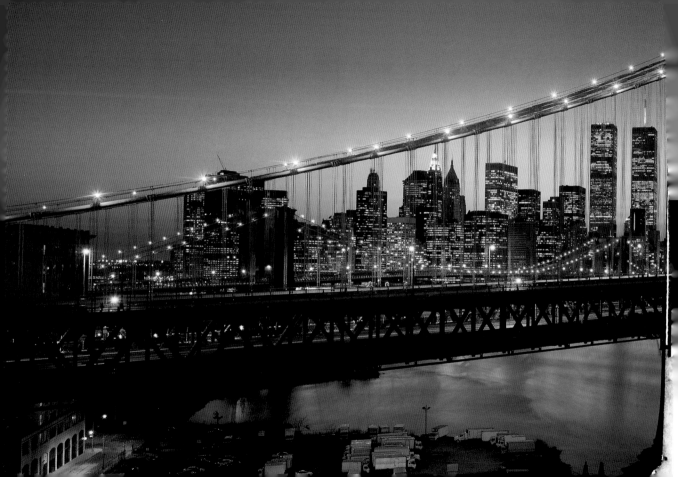

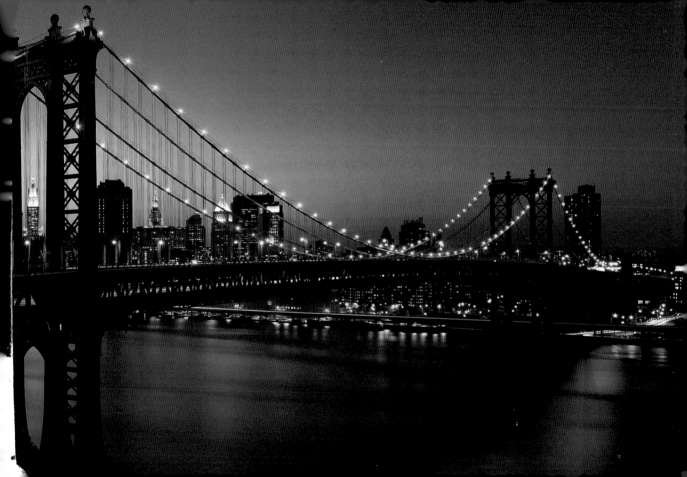

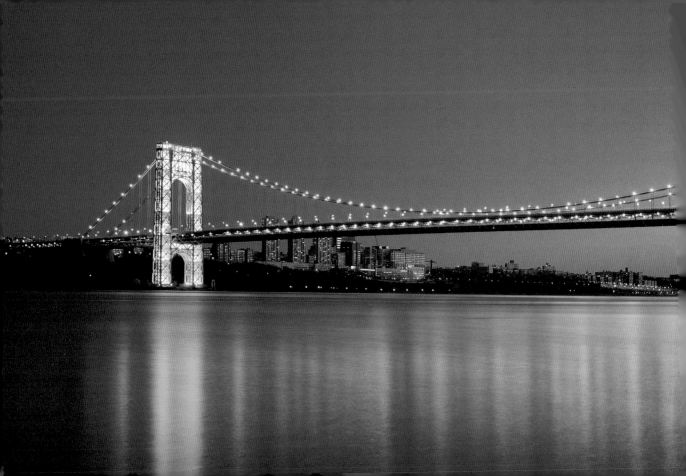

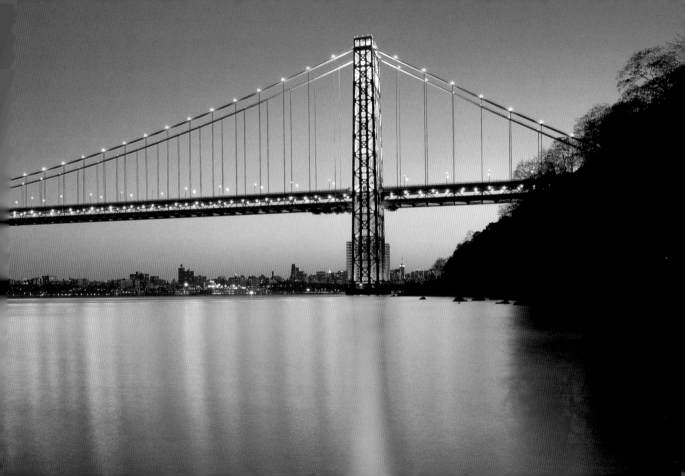

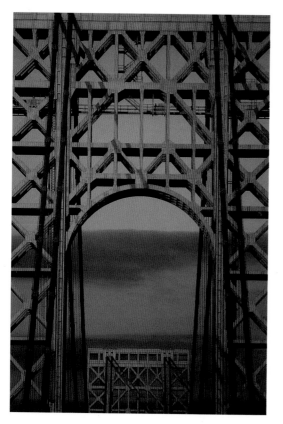

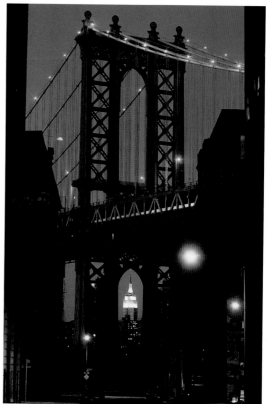

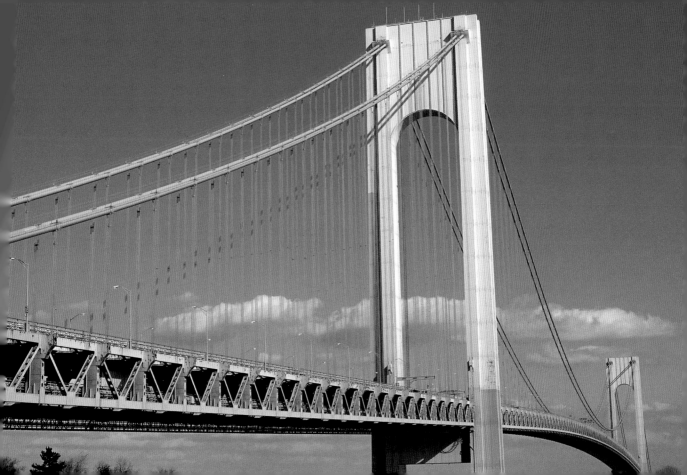

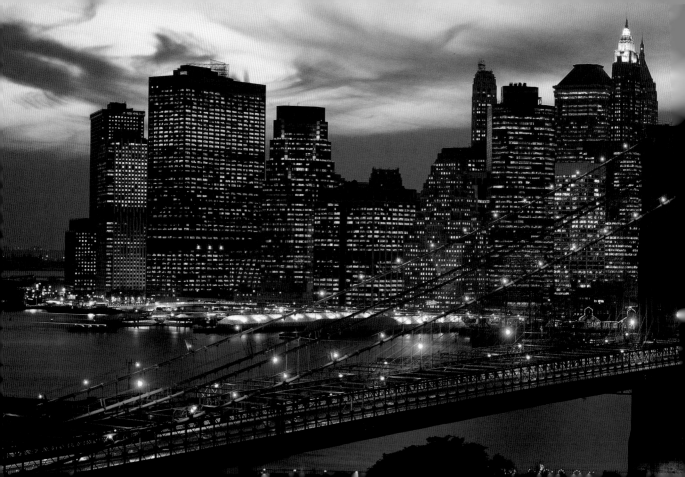

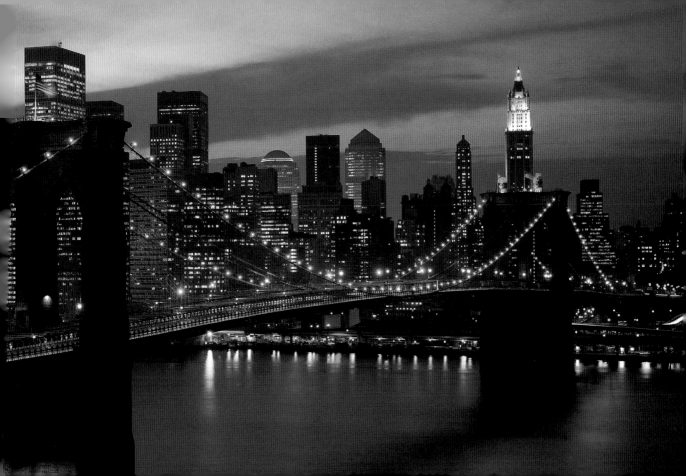

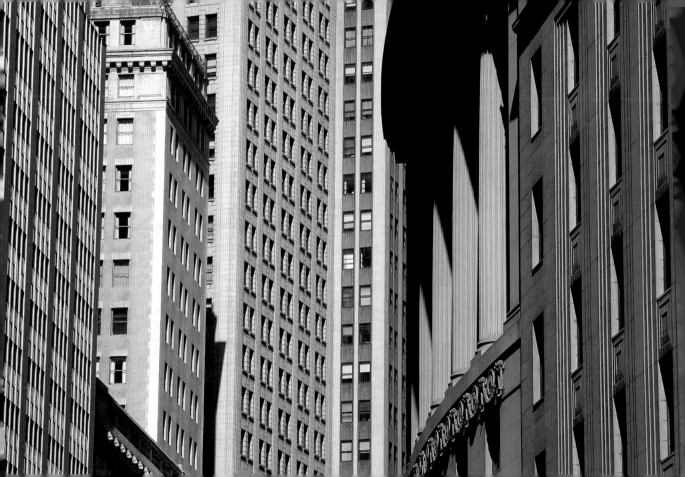

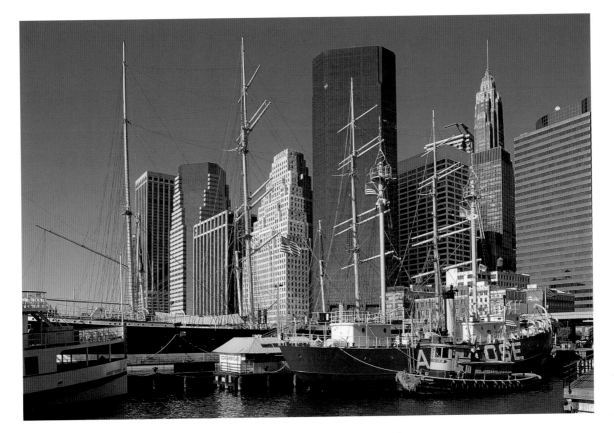

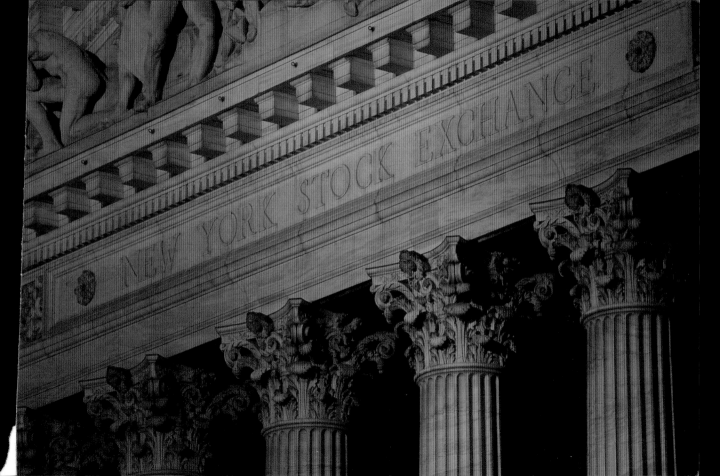

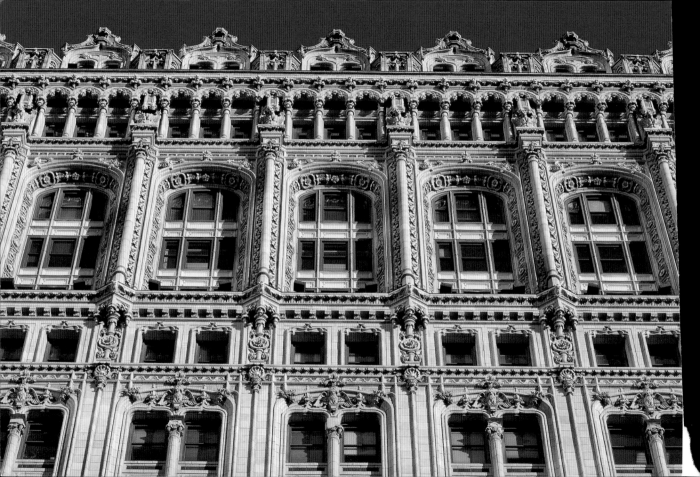

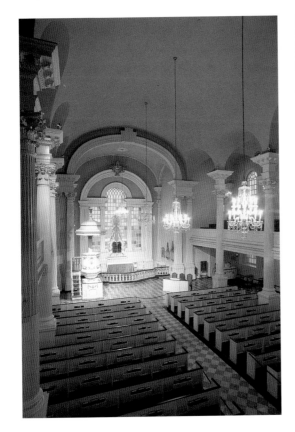

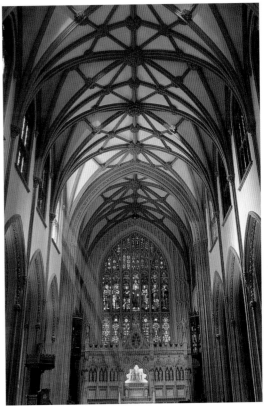

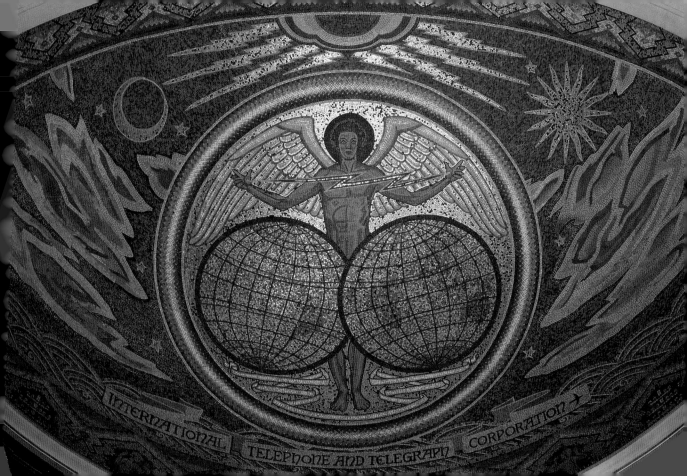

INTERNATIONAL TELEPHONE AND TELEGRAPH CORPORATION

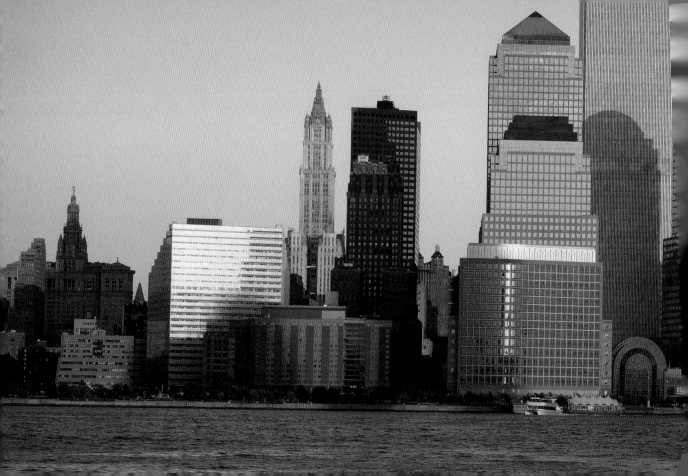

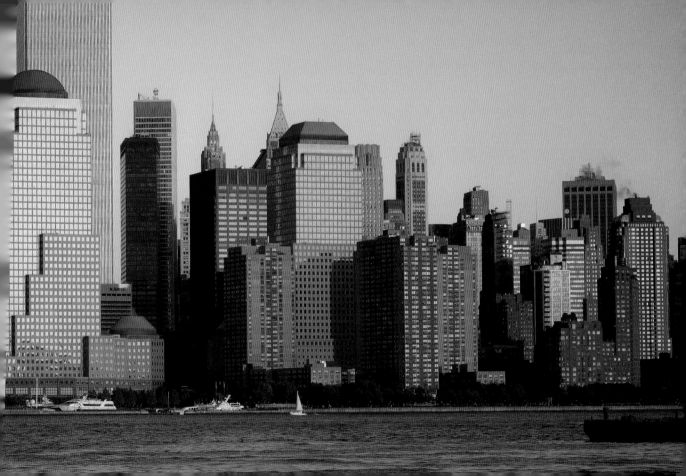

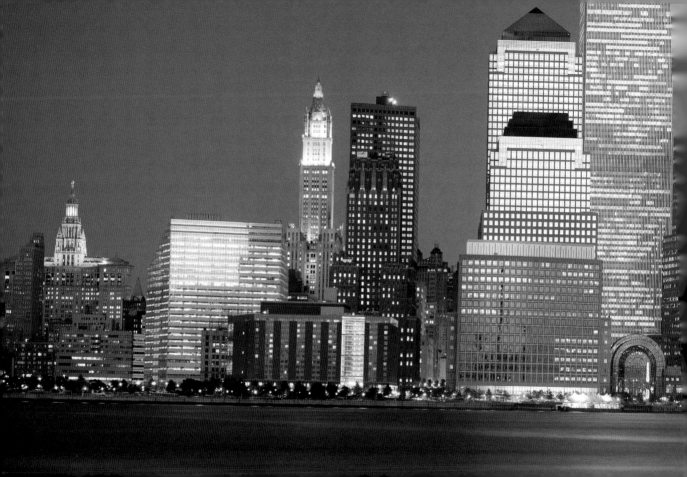

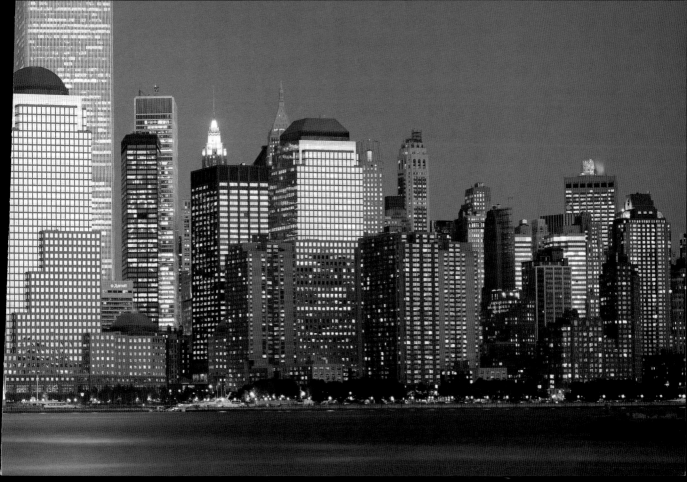

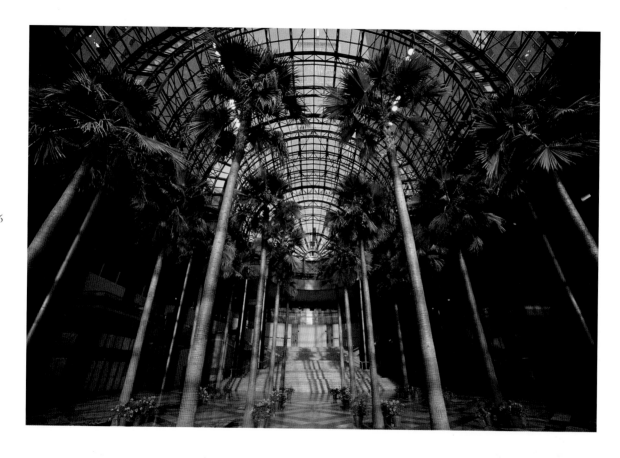

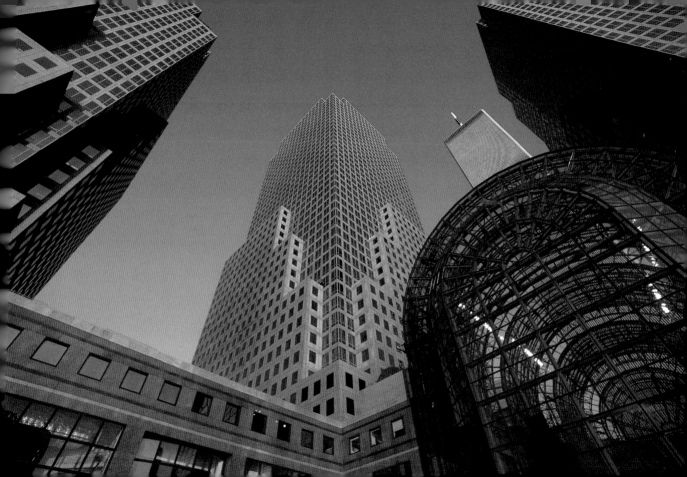

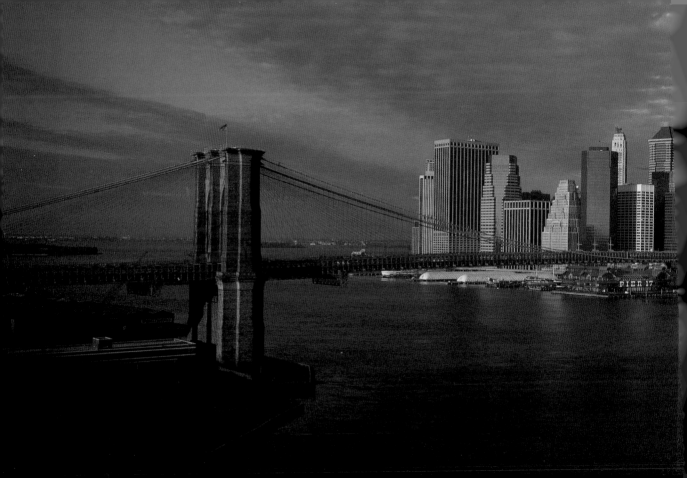

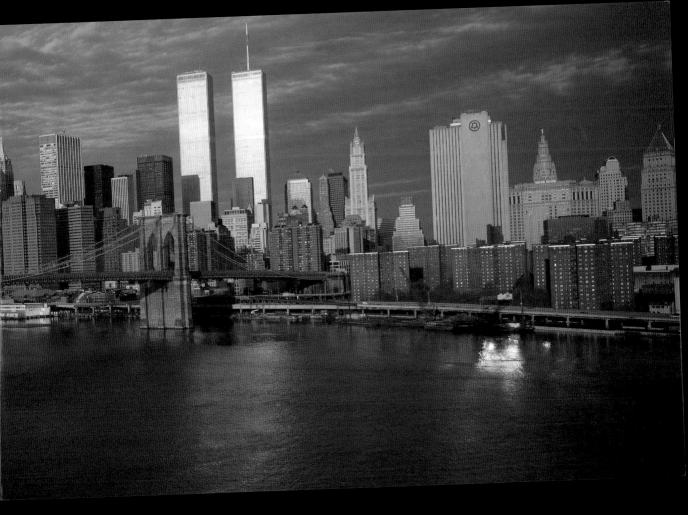

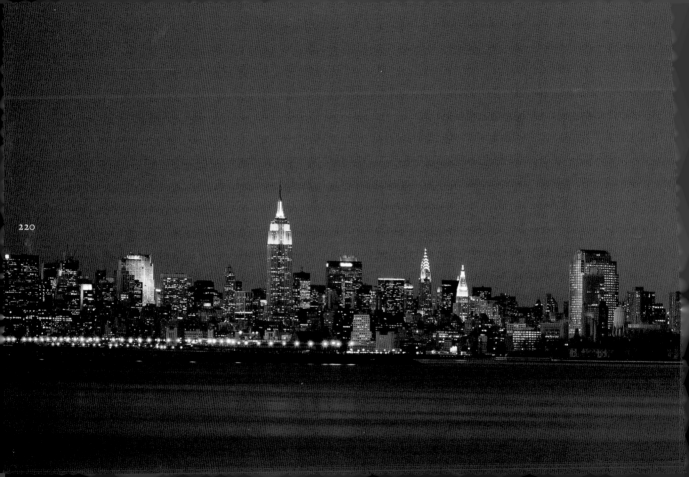

220

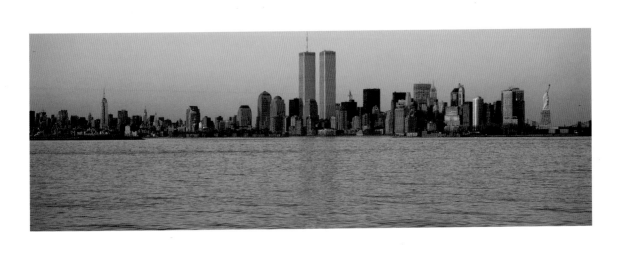

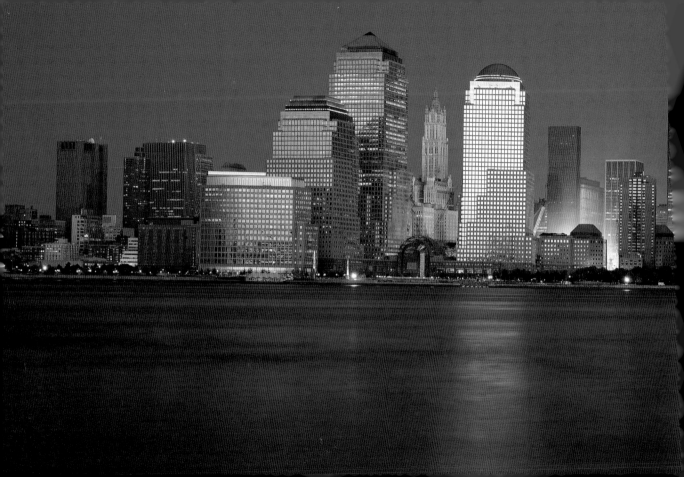

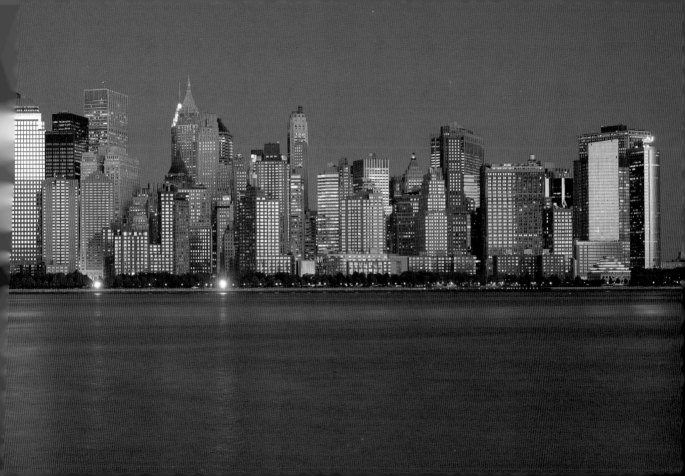

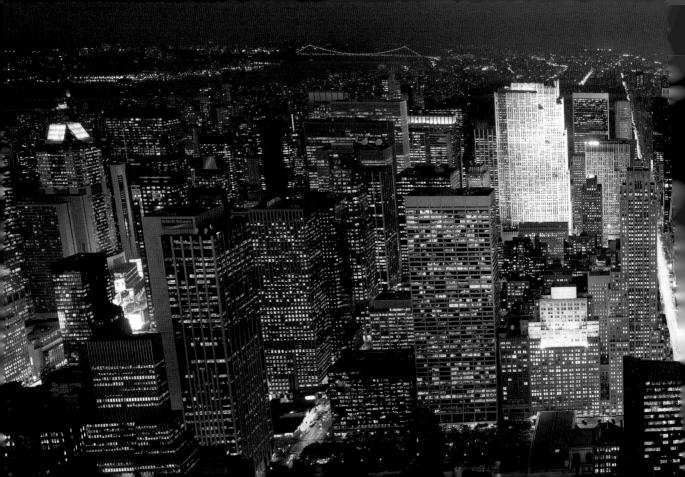

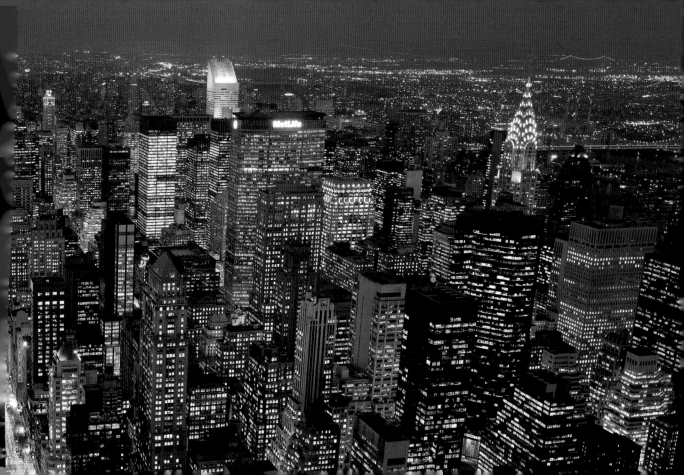

INDEX

233

235

237

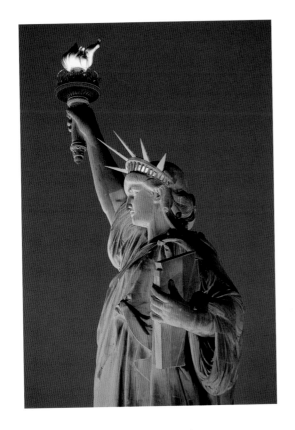

First published in the United States of America in 2003
by UNIVERSE PUBLISHING
A Division of Rizzoli International Publications, Inc.
300 Park Avenue South, New York, NY 10010
www.rizzoliusa.com

Rizzoli Editor: JESSICA FULLER

Produced by Welcome Enterprises, Inc.
6 West 18th Street, New York, NY 10011

Project Director: KATRINA FRIED
Designer: GREGORY WAKABAYASHI
Assistant Designer: NAOMI IRIE

ISBN: 0-8478-2576-0
Library of Congress Catalog Control Number: 2003104979
2003 2004 2005 2006 2007 / 10 9 8 7 6 5 4 3 2 1

To puchase original prints by Mr. Berenholtz, please contact
Welcome Enterprises at 212.989.3200

Printed and bound in China

ACKNOWLEDGMENTS

A special thank-you to my family and friends
for their encouragement and support:
Jim Berenholtz, Nanette Cohen, Gerald Kantor,
Mickey and Lindsey Spatz, John Steffy, Catherine Noren, Jon Ortner,
and Deborah Fliss.

I also wish to express my gratitude and appreciation
to my friends at Rizzoli and Welcome Enterprises:
Charles Miers and John Brancati, who shared the vision and said, "Yes!";
Lena Tabori, without whom this book could never have been done;
Katrina Fried, for her tireless efforts; and Gregory Wakabayashi, the best designer
I've had the privilege of working with.

R. B.